Land of the Free

WHAT MAKES AMERICANS DIFFERENT

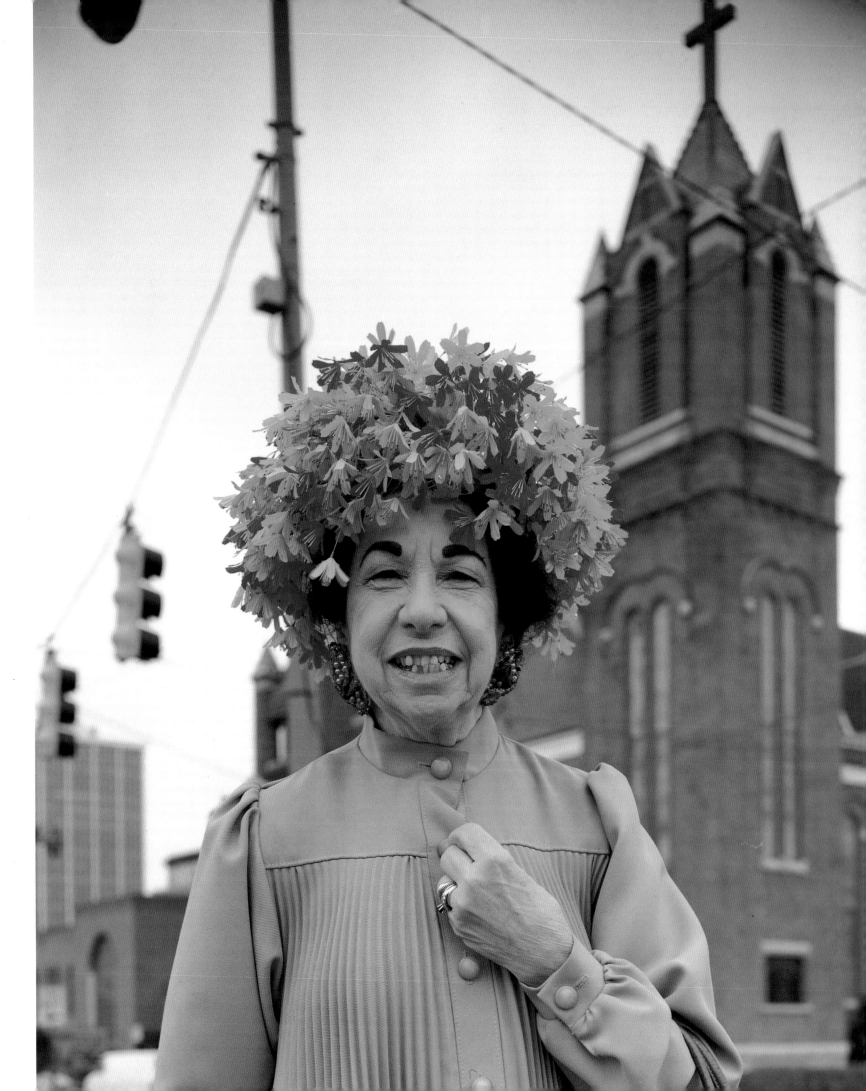

Land of the Free

WHAT MAKES AMERICANS DIFFERENT

★

PHOTOGRAPHS BY
DAVID GRAHAM

★

COMMENTARY BY
ANDREI CODRESCU

★

APERTURE

*S*o many acknowledgements seem both expected and hollow. I know I face this danger now. Nonetheless, I would like to make an attempt at thanking the people who made this book a possiblility.

Without a doubt every person photographed for this book, whether represented in the final selection or not, was integral to its final outcome.

My subjects were my inspiration and my direction. Their energy is what made the project move forward.

Their enthusiasm and desire to help me make good pictures raised the level of excellence. Their generosity in letting me into their lives and homes was limitless. Their kindness and friendliness made it possible for me to work with a clear mind.

I thank them in every way that I can. I think of them every time I look at the book. I hope they love the pictures as much as I do.

To Xina,

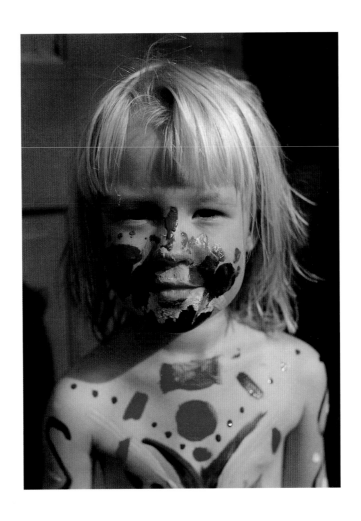

my girl and my fellow artist.

DAVID GRAHAM, ALL-AMERICAN
by
Andrei Codrescu

The people! Some love them, some hate them. David Graham loves them. He loves them enough to turn an affectionate but unsparing eye on their insistent need to transcend their plain "peopleness." In the hands of someone with a dimmer view of human nature, they would be monstrous; their need for dissimulation and kitsch would be turned against them, leaving scorched psychological ground where once there was flesh. David Graham refuses to moralize or condemn. He dignifies people by uncovering gentle and ironic mysteries in their evident bad taste and banality. The fat and wrinkles and bodily flaws of his subjects are not the wages of sin, just the plain record of late twentieth-century American life. The fat was made by white bread and gravy, barbecued burgers, Twinkies, and fried chicken. The wrinkles came from full engagement with children, jobs, and in-laws. The full range of advertised beauty aids is marshaled against the ravages of time, but not in any desperate, histrionic, over-the-top, all-out campaign. Flesh in all its aging pathos is not the seat of corruption but just a fact of life. Dressing up like someone else is another gentle palliative against the inexorable march of time, but it's not a desire to be someone else, to go against the grain of one's life.

People dress up like Elvis, Marilyn, Ben Franklin, or Scarlett O'Hara not because they believe that they are those pop figures, but because they want to enlist those ubiq-

uitous icons in an affirmation of their normalcy. They enlist the icons of their youth in the service of a cultural argument. Nobody's crazy, but everybody has something to say. Everybody's information comes from the same sources as everyone else's, just like the water in the kitchen taps and the electricity that powers the lawnmowers. A disaffected bohemian might run screaming from the ordinariness and earnestness of this world, but Graham's genius is to recognize the human decency of these people, which is grounded in their lawns before their trailers or suburban houses. They are being tourists without embarrassment, masquerading without self-consciousness.

Some of them are certainly weird and disturbing and may very well be sociopaths, but their weirdness is rooted in the same yearning for participation as everyone else's. The beauty of Graham's subjects is that they strive for happiness. This is what makes them American.

These Americans trust David Graham. They look straight at him, they allow him to pose them any way he wants. They trust him because they know somehow that he won't betray them, even if he makes them look funny. The people know that they are funny, they know what camp is, they know more levels of irony than a French intellectual because they watch American soaps. At the same time, they don't want anyone to laugh at them; they want others to laugh with them at what they have wrought. They trust David to

know this, unlike some "foreener" who might misinterpret the whole thing and turn them into freaks.

David Graham understands this. And he has his own ideas about the whole thing. He makes ordinary Americans look foreign. He makes them as exotic as tribesmen from some remote region. The irony, of course, is that these would-be tribesmen have day jobs and that their fantasy world is made from the flotsam and jetsam of popular culture; their wardrobes are made up of the pure products of Goodwill stores and discount outlets.

Look at the scantily clad circus performer posing proudly on the steps of her trailer. The defiant hand on her hip and her frank gaze are mirrored by the llama chained up behind her. Like the llama, she is proud of her natural beauty, but she is at least a step and a half above the llama because her beauty, unlike the llama's, is enhanced by jewelry, a fine hairdo, silver shoes, and hard work. She has risen above the llama by sheer grit and is proud of her tiredness, barely masked by mascara and lipstick. And unlike the llama, she is not fastened by a chain to the trailer. Her chains dangle freely from her neck and arms and hair, like symbols of broken bondage. She is self-made, while the llama is, well, just made. The trailer is temporarily parked here, where the (doubtless temporary) job is. Any moment now, the whole assemblage of llama, trailer, and stripper will take off, leaving the grass barely disturbed. This is America: there is enough grass to park in and to let your llama graze.

I am a foreener. David and I were paired in the making of a book called *Road Scholar*, the record of a transcontinental journey that was my attempt to understand Americans. To me, these people were and are exotic. But as the poet Ted Berrigan used to say, "Nobody is a character to themselves."

I am quite normal to myself and immensely amused by the eccentricities of others. David's fundamental belief in the virtues of normalcy meshed quite nicely with my suspicion of them. I met people who had deliberately put themselves outside the mainstream, but I decided that, in the end, the fact that they were Americans overrode whatever proto-philosophy they were espousing. David knew this instinctively: he photographed their Americanness, which shone out of their freakiness like a Day-Glo beacon. Typically, my reactions to Las Vegas were filled with doubts about the ethics of this artificial paradise. David's pictures affirmed its imaginative and ironic facts, without any teleological qualms. Both of us, however, were enthralled by its energy and found the forms tonic and amusing.

My first impulse on viewing a David Graham photograph is to laugh. My second is to note the pathos. He is an insider who photographs the desire of insiders to create an outside for themselves. I am an outsider and fear insiders, but in looking at David's people I find such notions spurious. These are people. You love them or you hate them. David loves them. I love some of them, and I'm learning from David how to tolerate the rest.

This collection, titled ironically (and typically) *Land of the Free: What Makes Americans Different,* shows the full range of David's artistry. What makes Americans different is their fierce sense that they are free. When they exercise that freedom they fall exuberantly into the arms of a vast commercial culture full of images and clichés. It is in that embrace that David's camera finds them. They allow him to photograph that *jouissance* because they are proud of it. What is freedom without practice? However, one should not, and I don't, underestimate the raw energy of these Americans' playfulness. One ought to, and I do, praise popular culture for giving it a million outlets. There is a barely contained violence just under the surface. The housewife in the photograph entitled *Machine Gun Shoot* is holding a real machine gun.

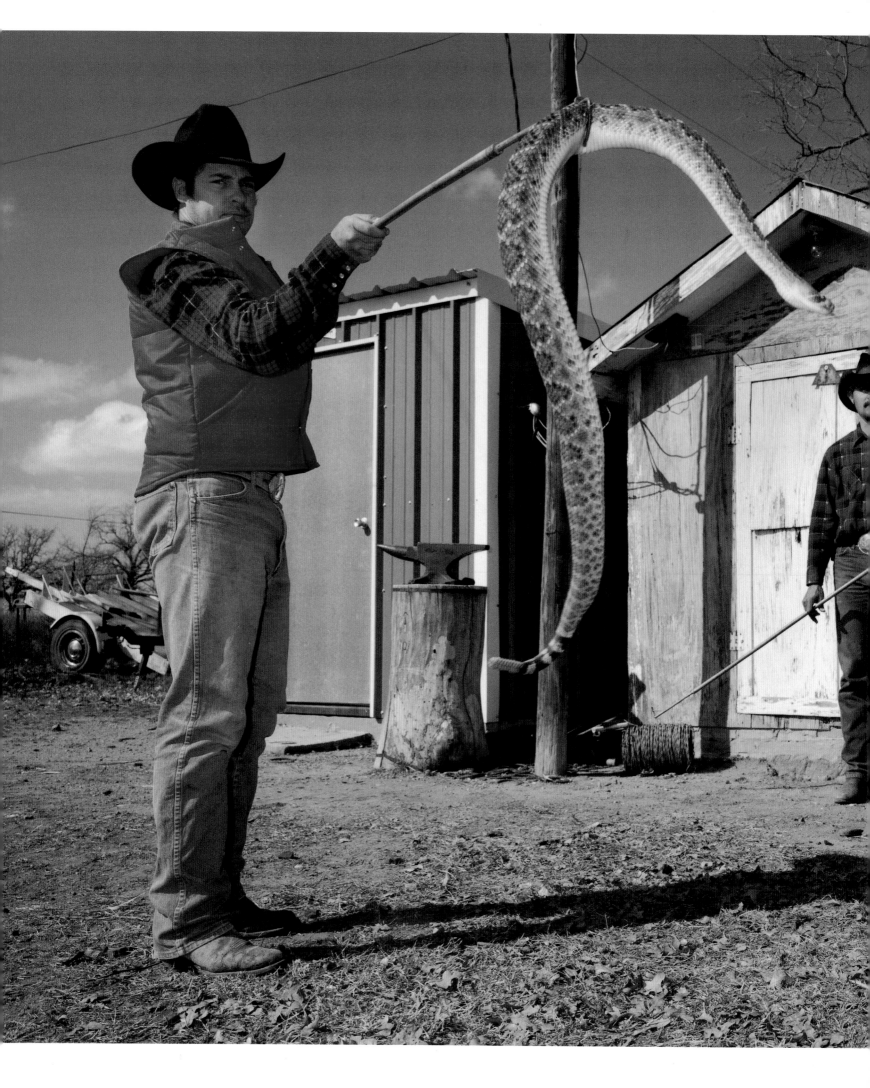

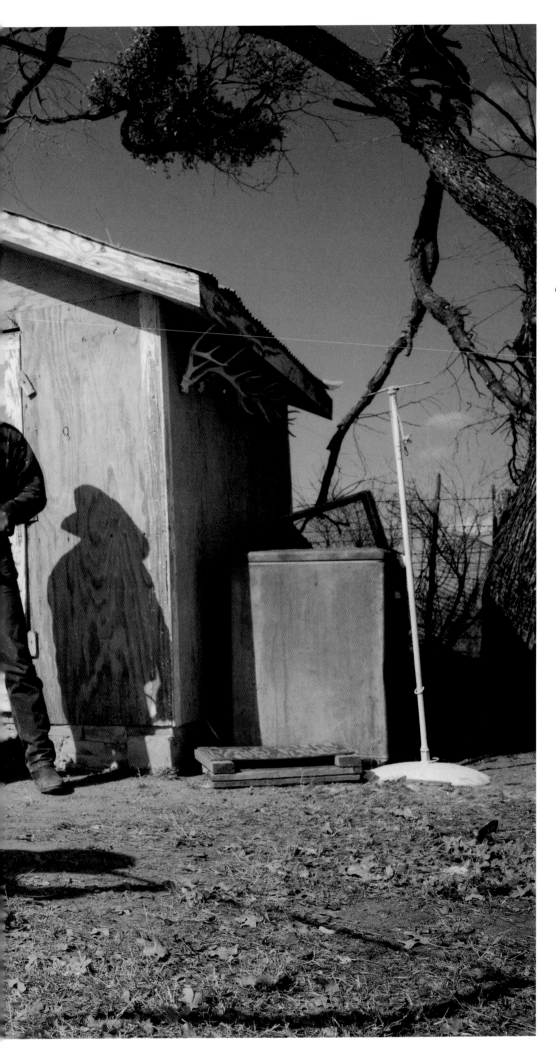

At work and play

Some work looks like play. The sideshow veteran driving a nail into his nose and the stripper in her dressing room are hard workers. It's no picnic catching a huge rattlesnake either, or practicing for ballet. These workers have discovered that work can be fun, a notion so startling to the drudgery of everyday toil that it seems like a provocation. And it is. Since the middle of the nineteenth century, Americans have been delighted, provoked, and allowed to dream by small entrepreneurs, con men, circus freaks, and oddballs. These workers of kitsch miracles hold out the hope—nearly extinct in these days of über-efficiency—that one can make a living imaginatively, performing nonrepetitive tasks that depend for their success on a sense of wonder.

All these people at work-play or play-work seem to issue an invitation to the viewer. They are seductive because that's part of the job. But make no mistake, their skills go deep and have been acquired the hard way. That's an awfully big nail going up that nose, and how close do we really want to get to that rattler?

Frontispiece: *Willie Oats*, Little Rock, AR
Opposite: *Quinn Jones and Danny Dominguez*, Mason, TX

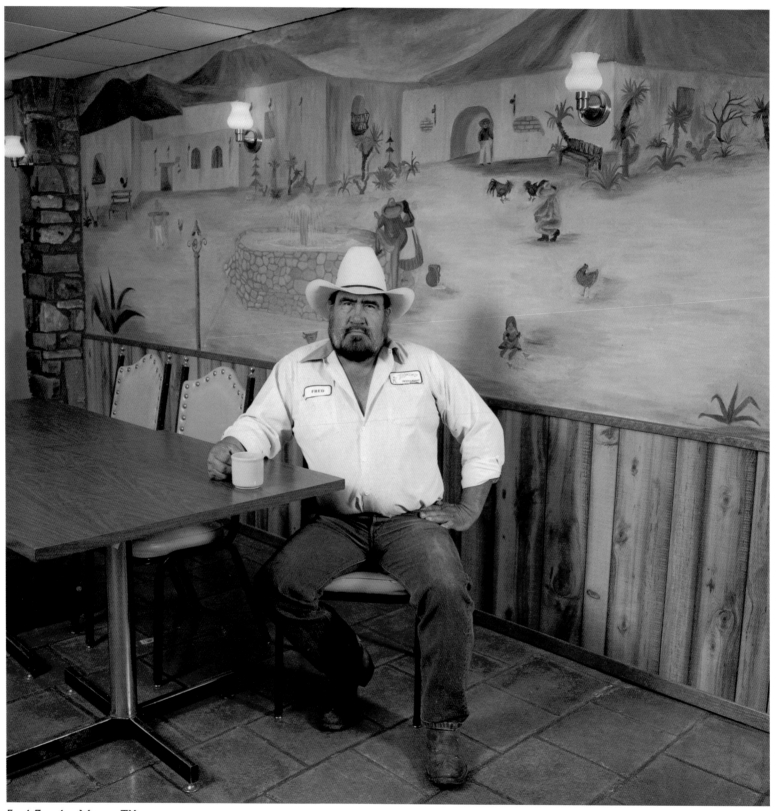

Fred Zavales, Mason, TX

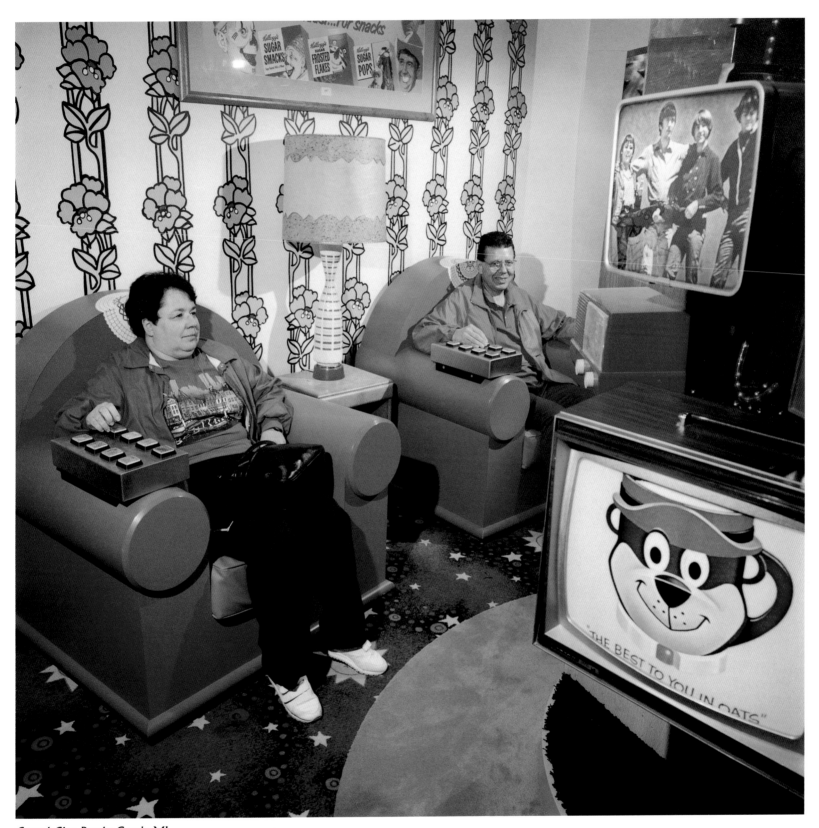

Cereal City, Battle Creek, MI

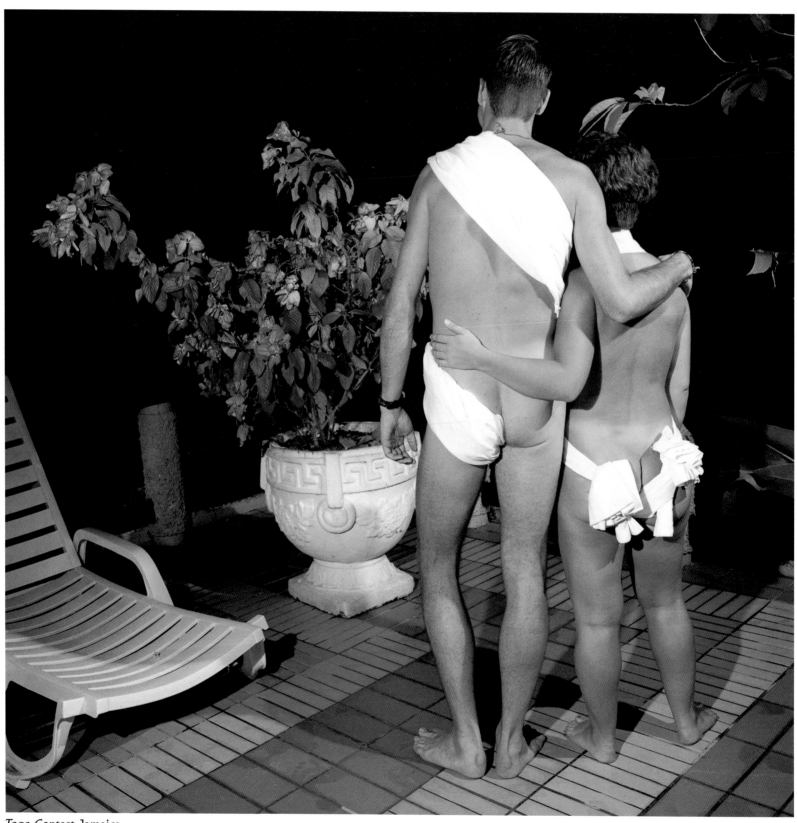

Toga Contest, Jamaica

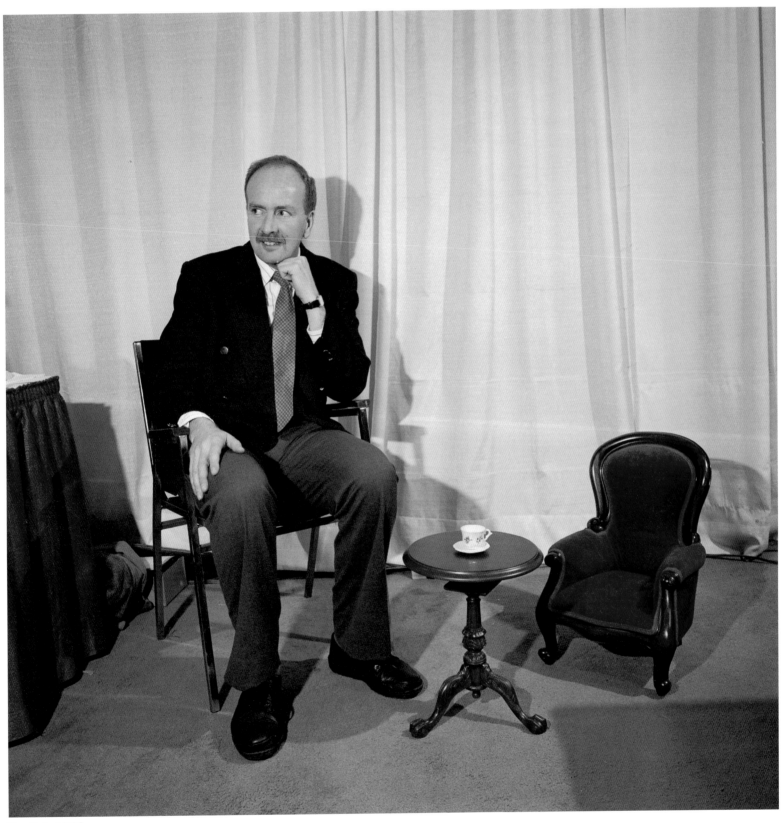

Toy Fair, NYC

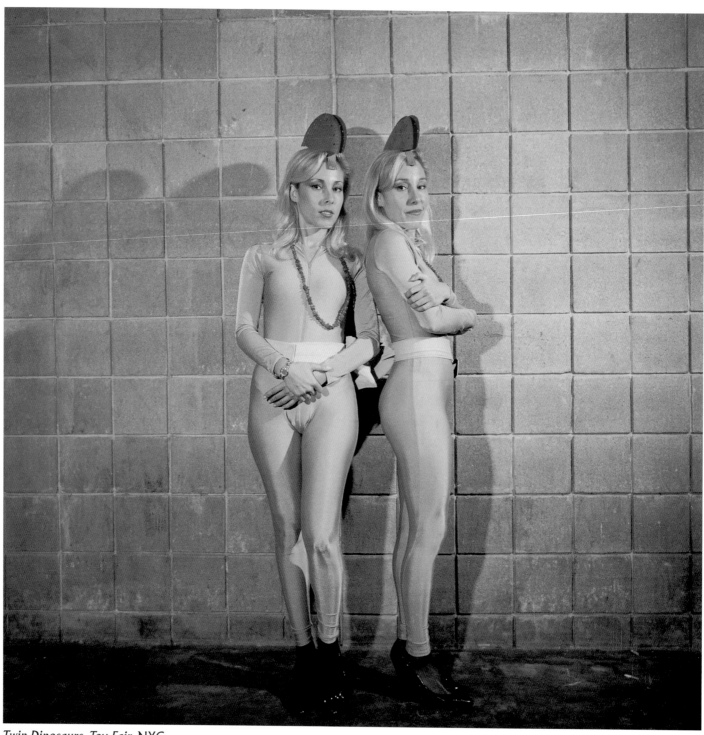

Twin Dinosaurs, Toy Fair, NYC

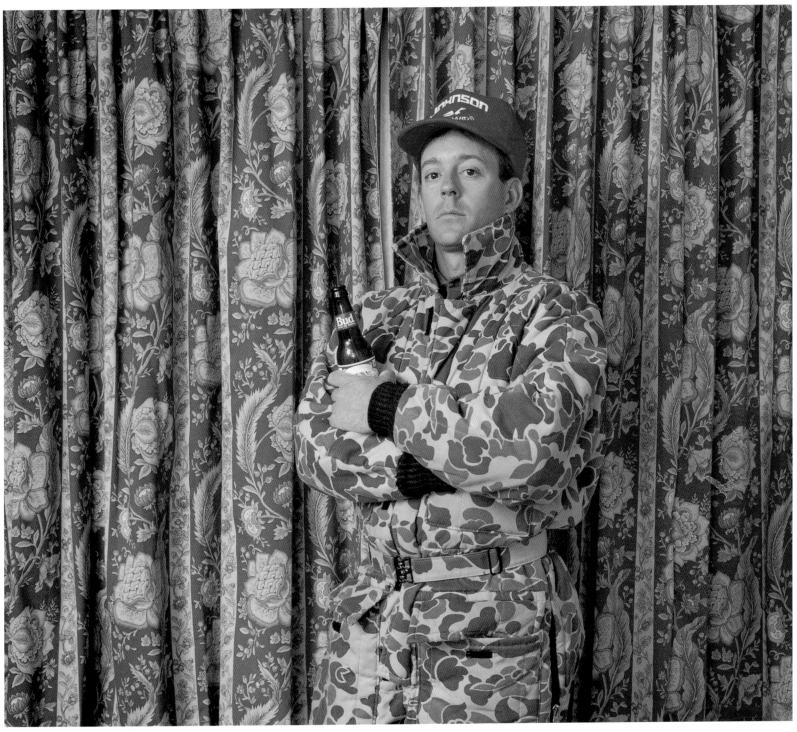

Bob Pastick, Lake Lanier, GA

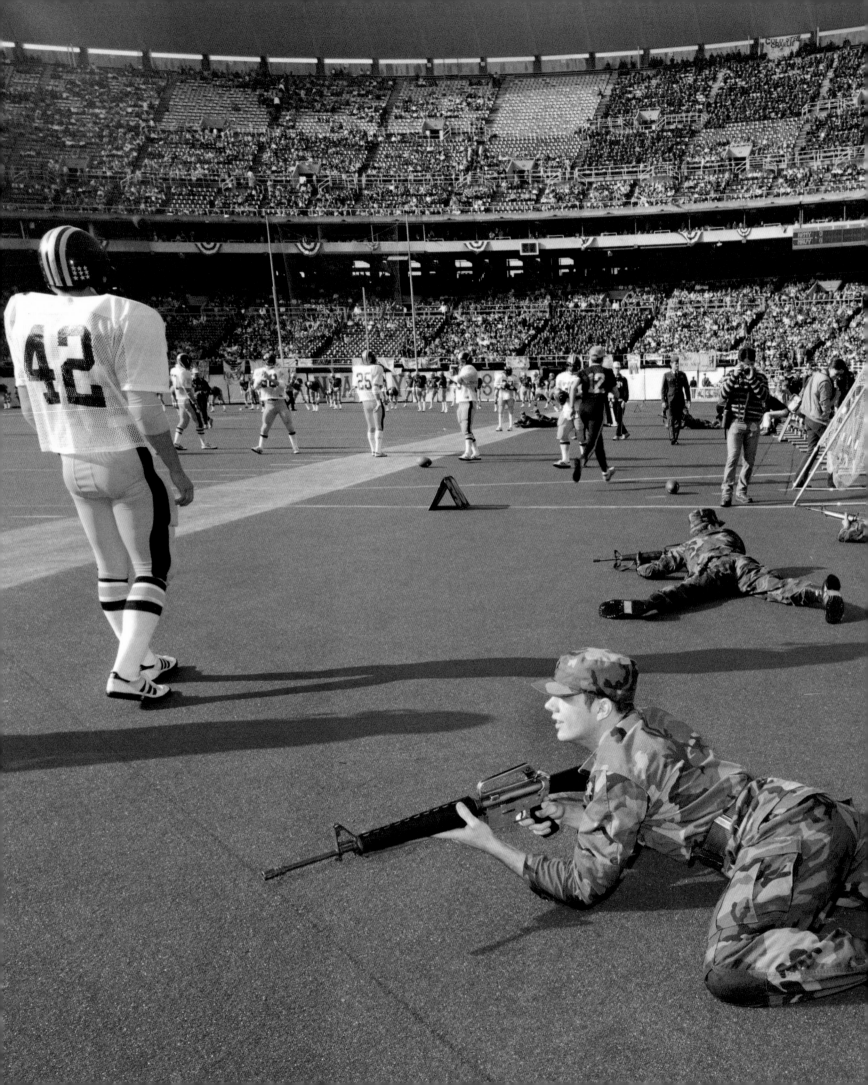

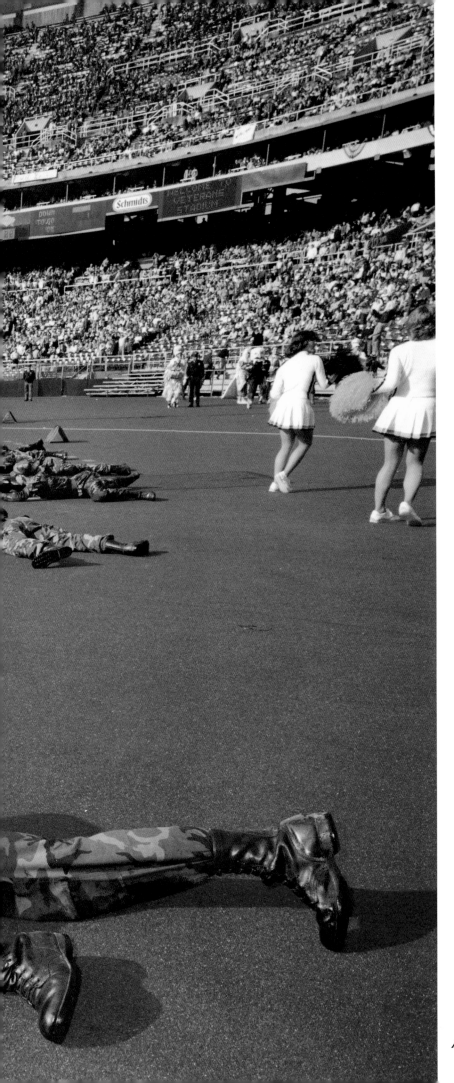

Army Navy Game, Philadelphia, PA

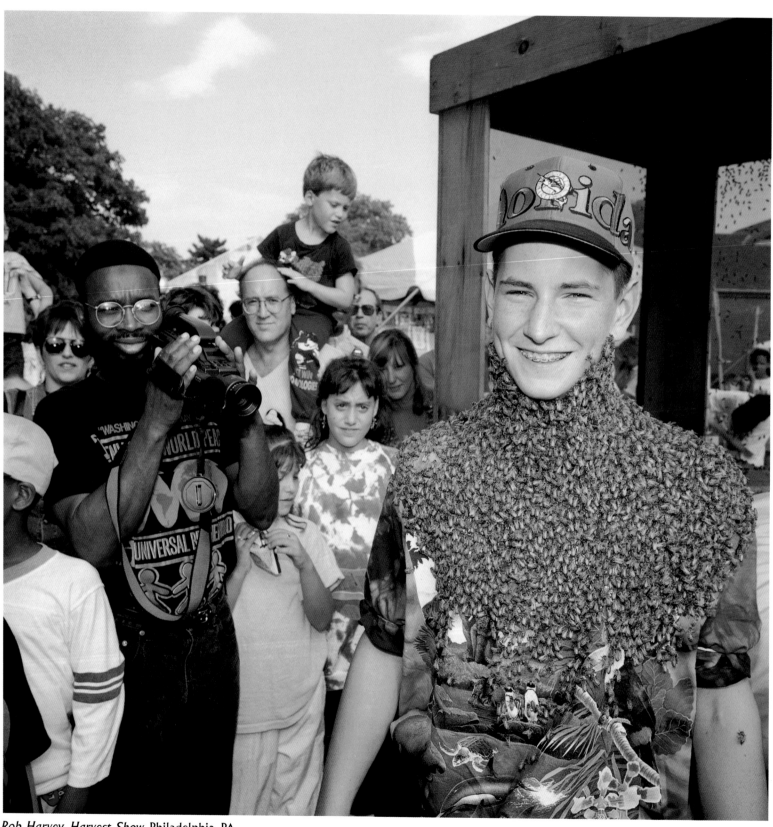

Rob Harvey, Harvest Show, Philadelphia, PA

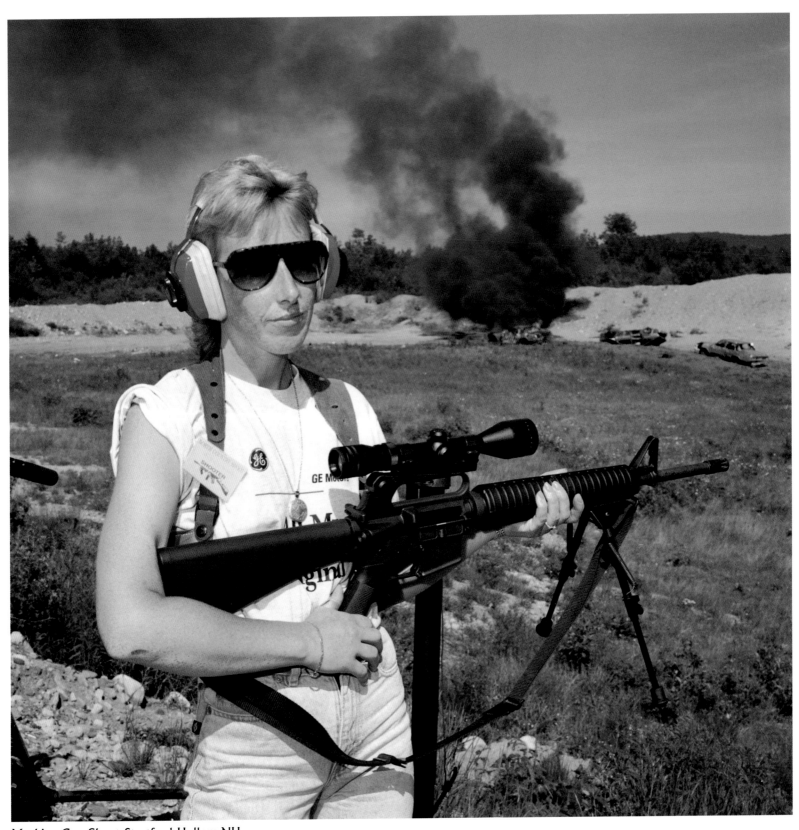

Machine Gun Shoot, Stratford Hollow, NH

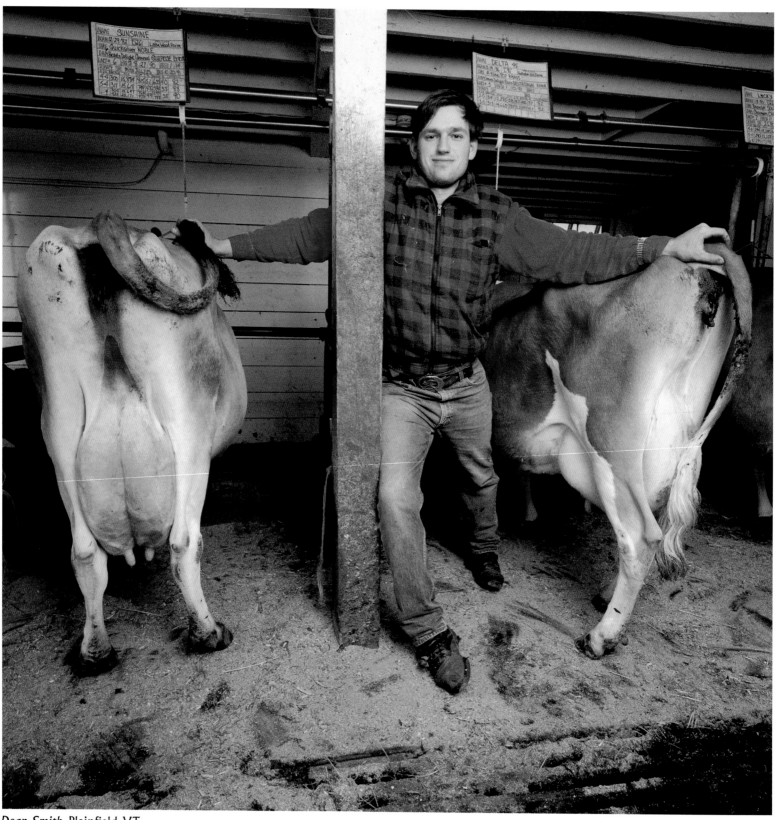

Dean Smith, Plainfield, VT

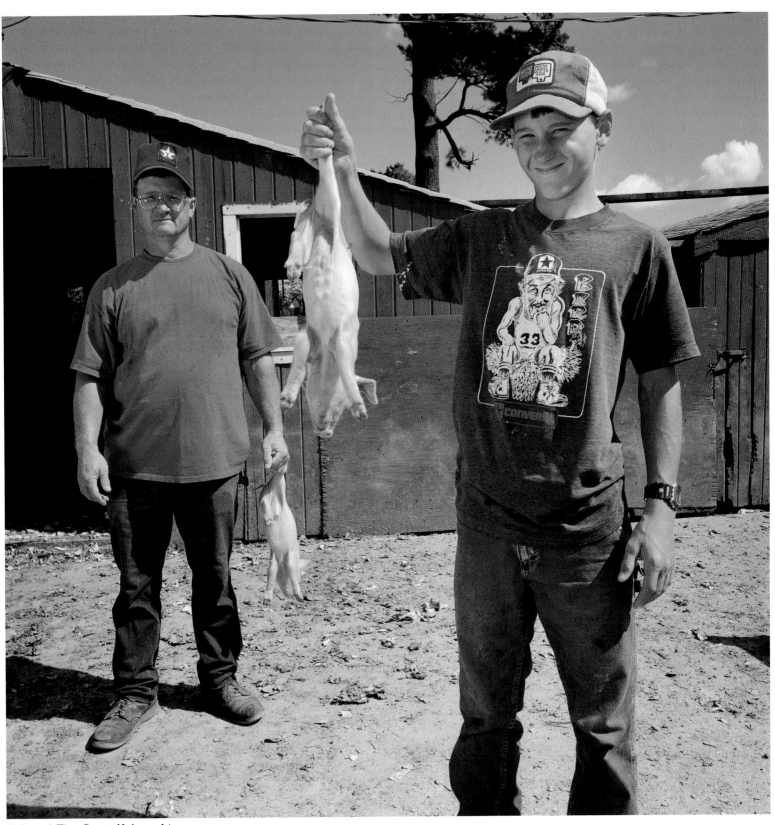

Bob and Tim Grout, Kalona, IA

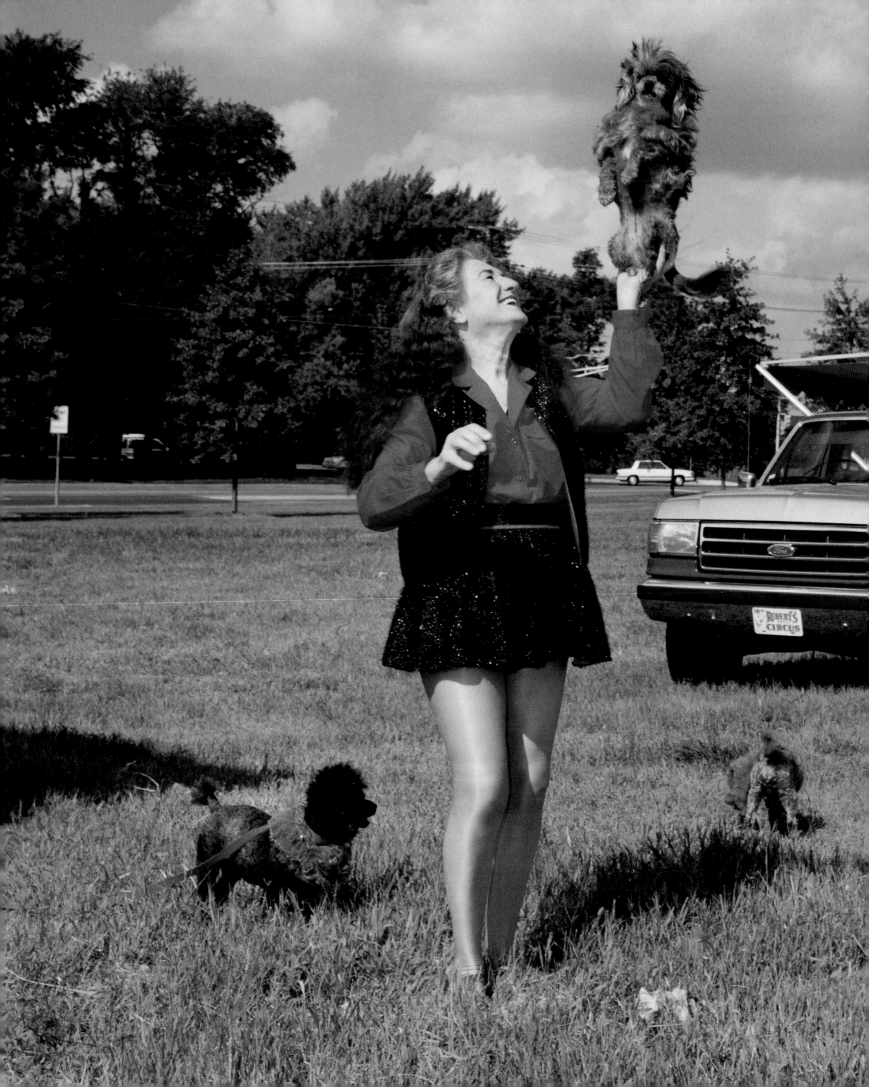

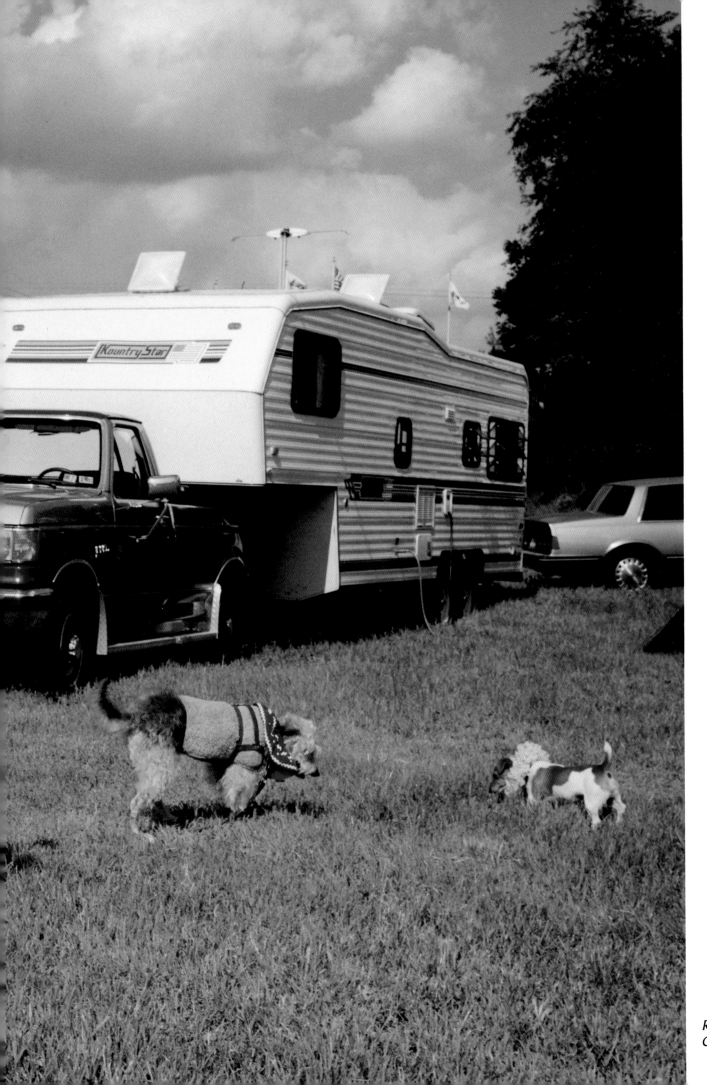

Roberts Brothers
Circus, Voorhees, NJ

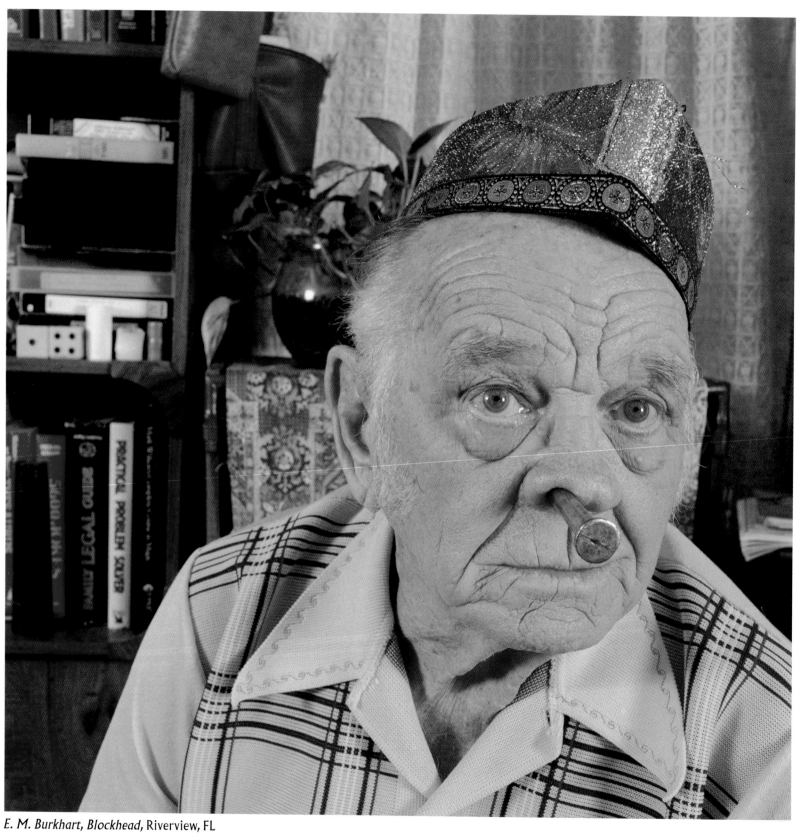

E. M. Burkhart, Blockhead, Riverview, FL

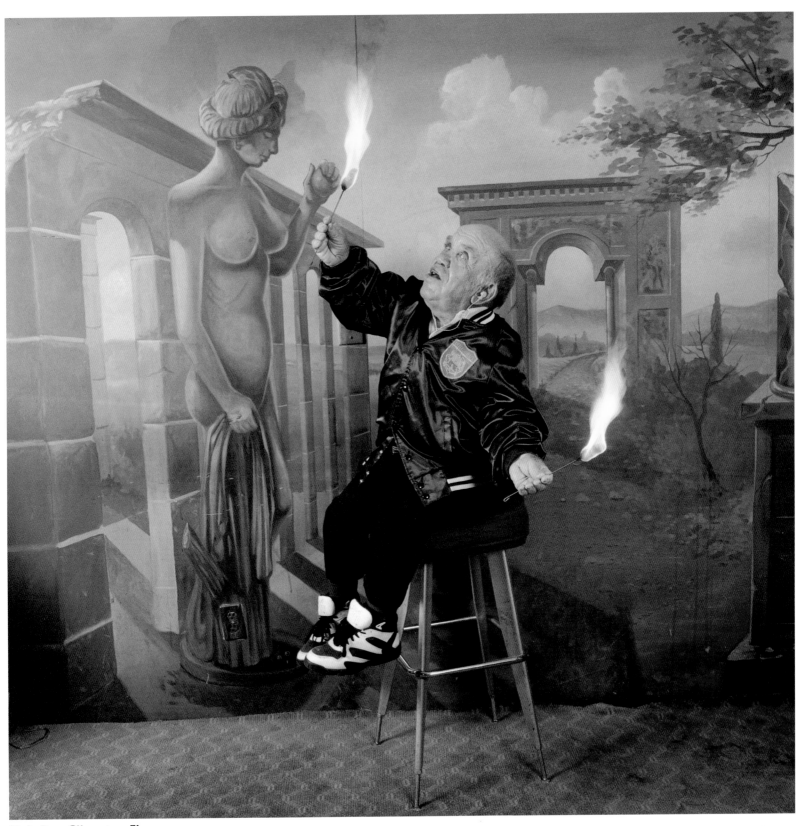

Little Pete, Gibsonton, FL

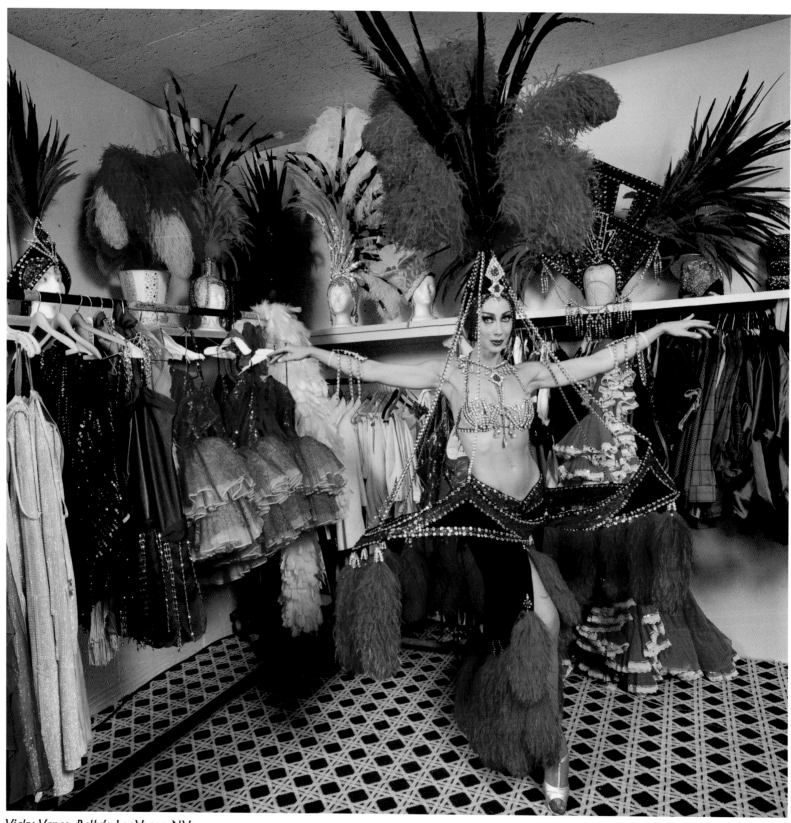

Vicky Vance, Bally's, Las Vegas, NV

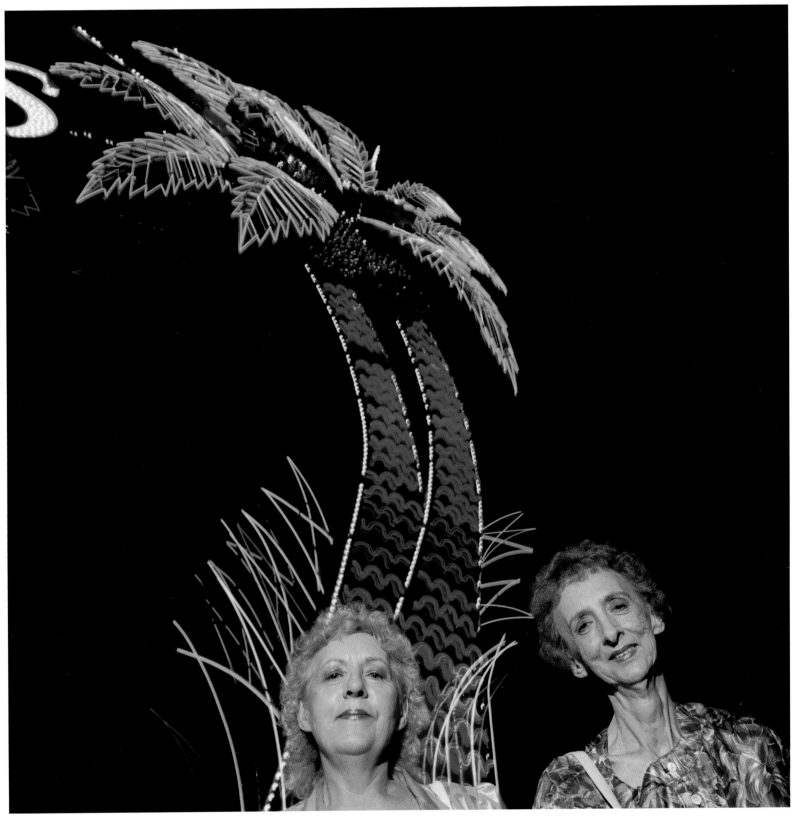

Las Vegas, NV

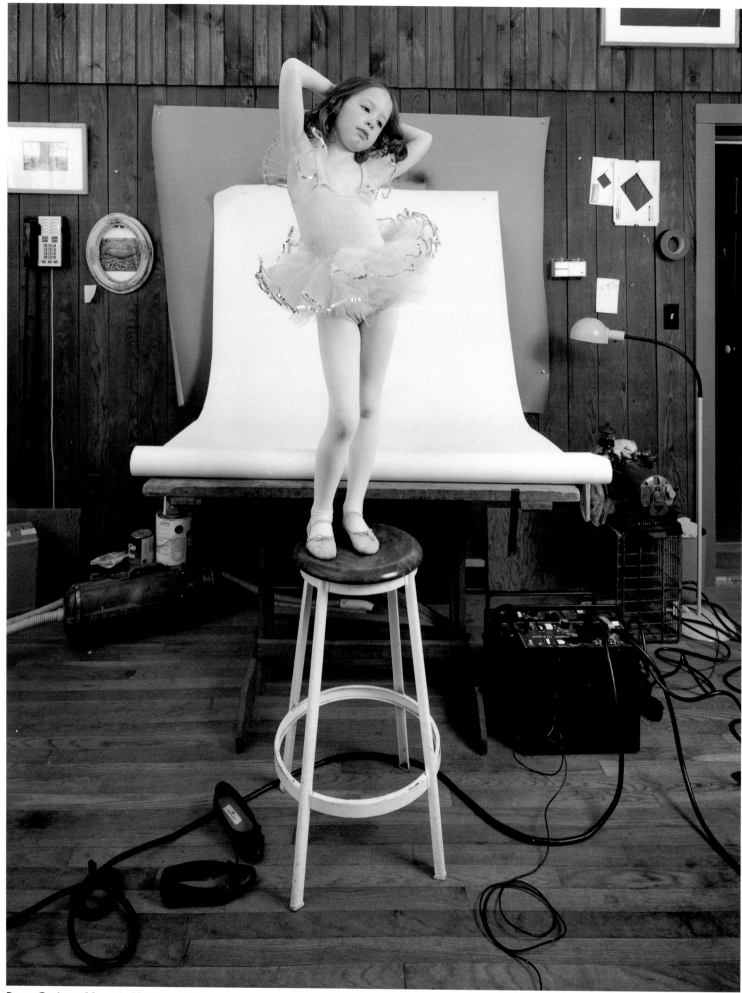

Dory Graham–Vannais, Holicong, PA

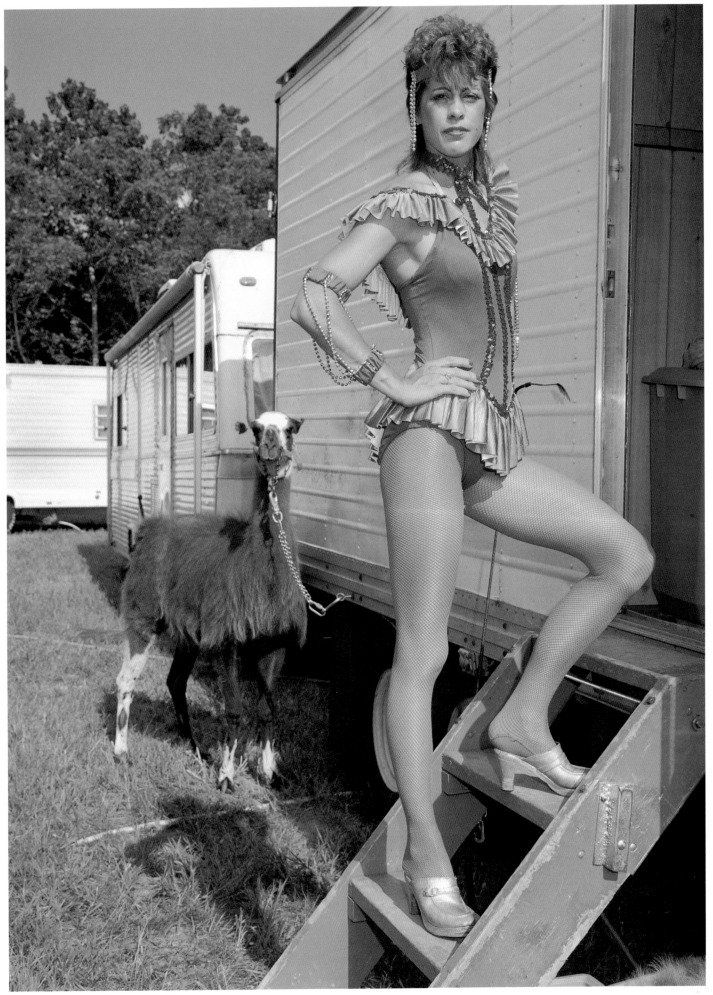

Roberts Brothers Circus, Voorhees, NJ

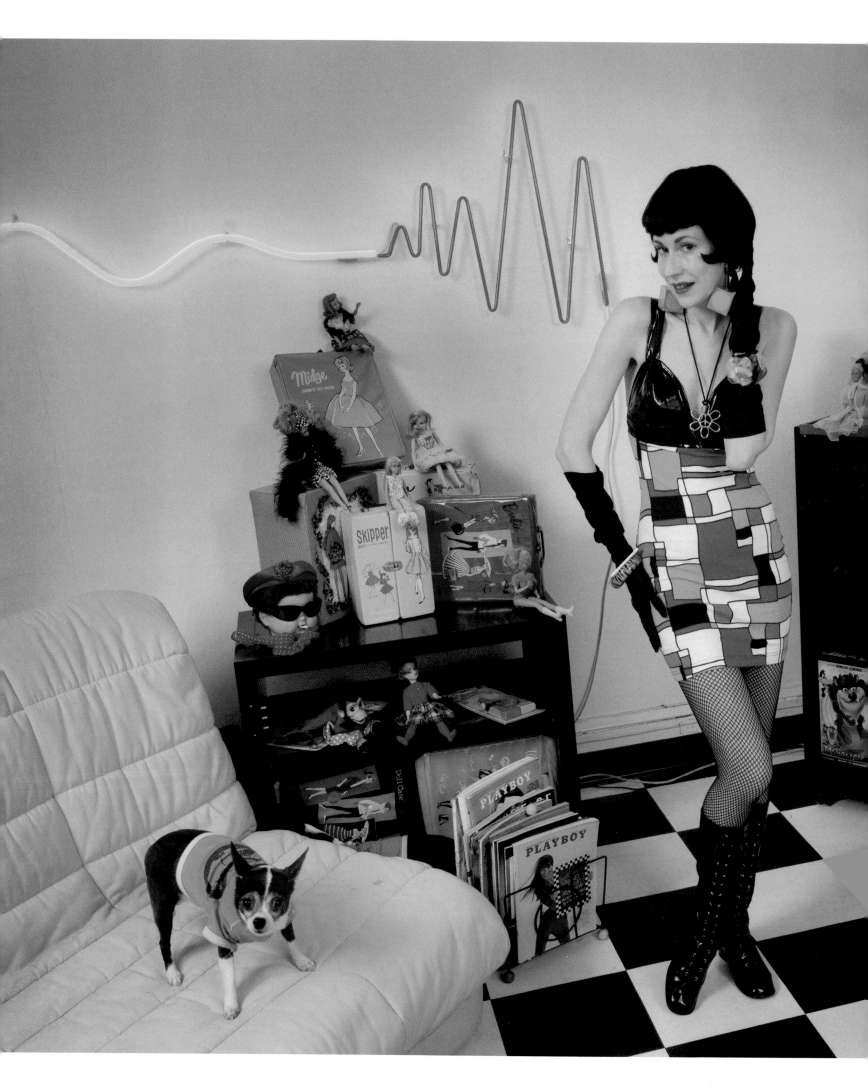

In costume

American history is young enough to have been photographed almost since its inception. Of course, no photographers were present at the signing of the Declaration of Independence, but we have viewed the scene so many times in countless re-creations that it is hard to believe that we have not seen a photograph of it. Other fundaments of our history were photographed: we have pictures of Lincoln and Walt Whitman, we have the Civil War, after which the camera never stopped clicking. American history, it seems, is synchronous with photography. The clothes and furnishings of our predecessors abound in our homes and attics. Consequently, Americans are addicted to dressing up. Here is George Washington in his boat launch, looking perfectly at ease. Ben Franklin sits in an armchair, unfazed by the cordless phone and portable TV next to him. A look of sly intelligence beams over his Ben Franklin eyeglasses, as if to say, "Yes, I invented these gadgets shortly after I died."

Impersonating great men seems to be the passion of, well, men. But the greater desire

Midge Mattel, Philadelphia, PA

by far is to impersonate familiar figures of pop culture. Among those, Marilyn Monroe and Elvis reign supreme. Elvis, like any great deity, is essentially androgynous. There are as many women Elvii as there are men. Monroe is a favorite of both women and men. Cross-dressing is an essential American right, like the right to pick up your house and move. In one of my favorite images, an impersonator (or is it a wax statue?) of Liberace holds a candelabra as if providing light for anyone wanting to play dress-up. A woman, barely out of the wax mold herself, poses stiffly in an armchair with a look of indecipherable glee on her face. A 1960s television set sits at the center of the scene like an altar. We are privy to the rituals of a new religion, with new gods, new images, and new (and barely defined) rules. It's kitsch, pure kitsch, but the feeling is historical. These people, and the others in this gallery of impersonators, are testimonies to the speed of American history. People who have moved us deeply, whom we barely understood, whom we laughed at, whose lyrics or camp gave style to a succession of adolescent rebellions, have never died, or not for very long anyway. Simply the American way is to resurrect, quickly. And here they are, the founders and the entertainers, back from the grave and impossible to distinguish from the originals.

Mike Memphis Lepore as Elvis, Brooklyn, NY

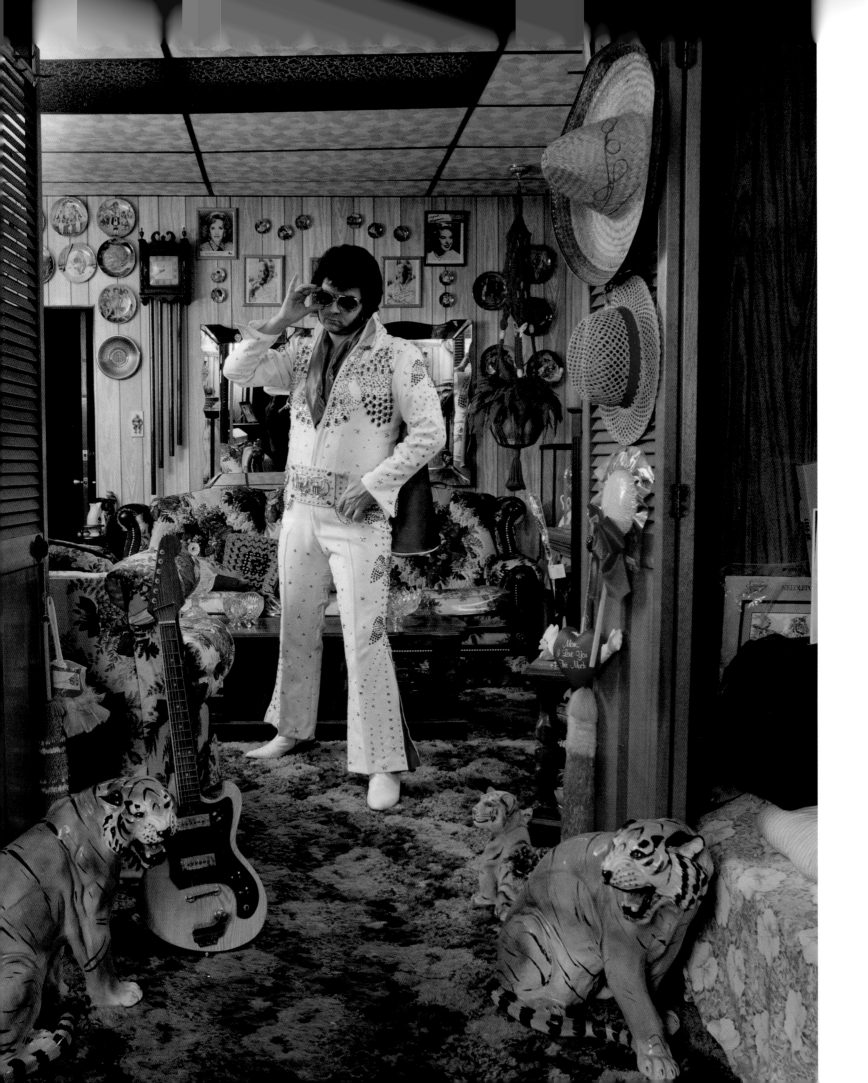

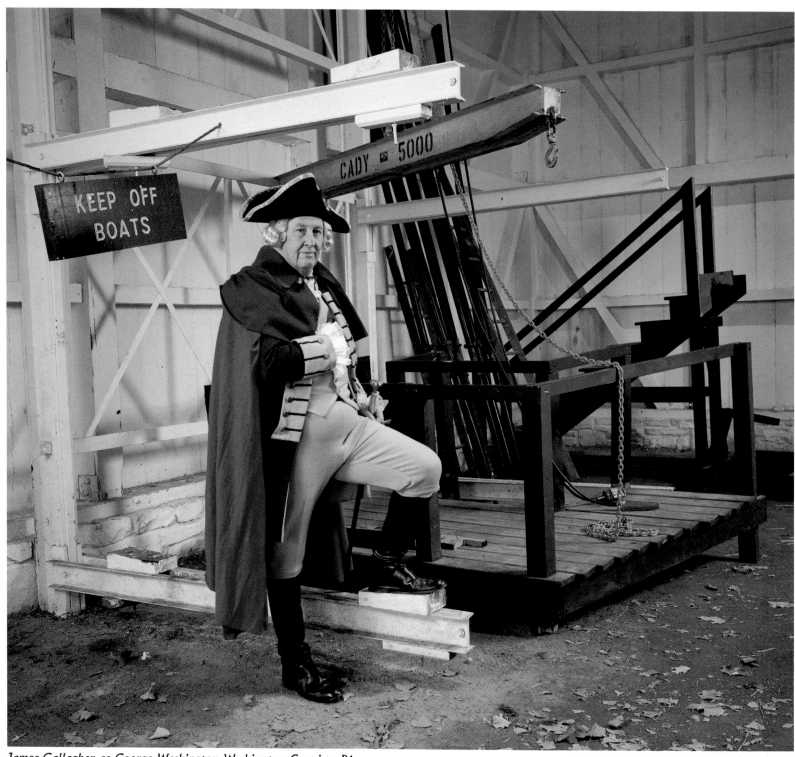

James Gallagher as George Washington, Washington Crossing, PA

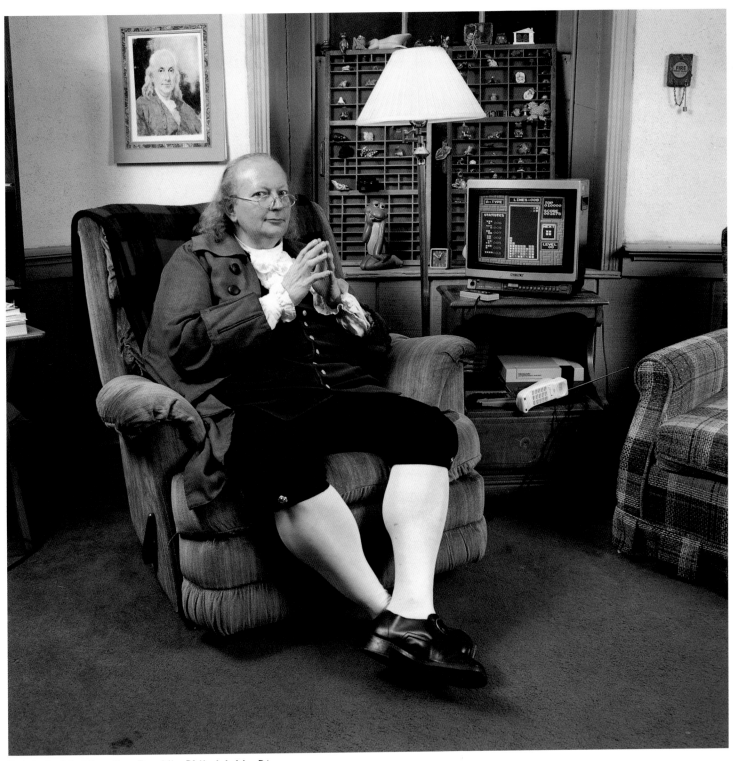

Ralph Archbold as Ben Franklin, Philadelphia, PA

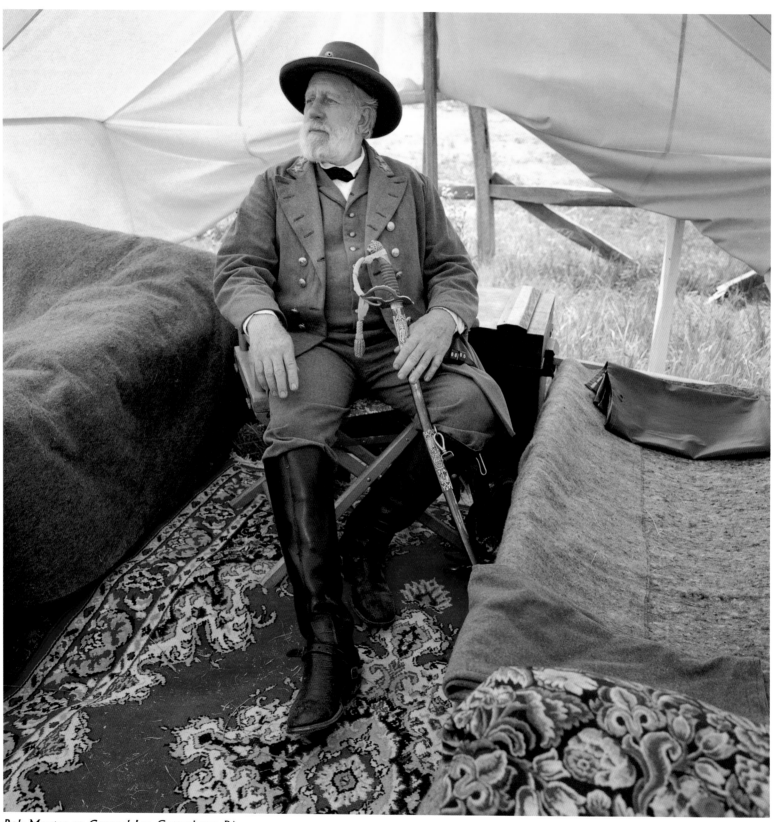

Bob Moates as General Lee, Gettysburg, PA

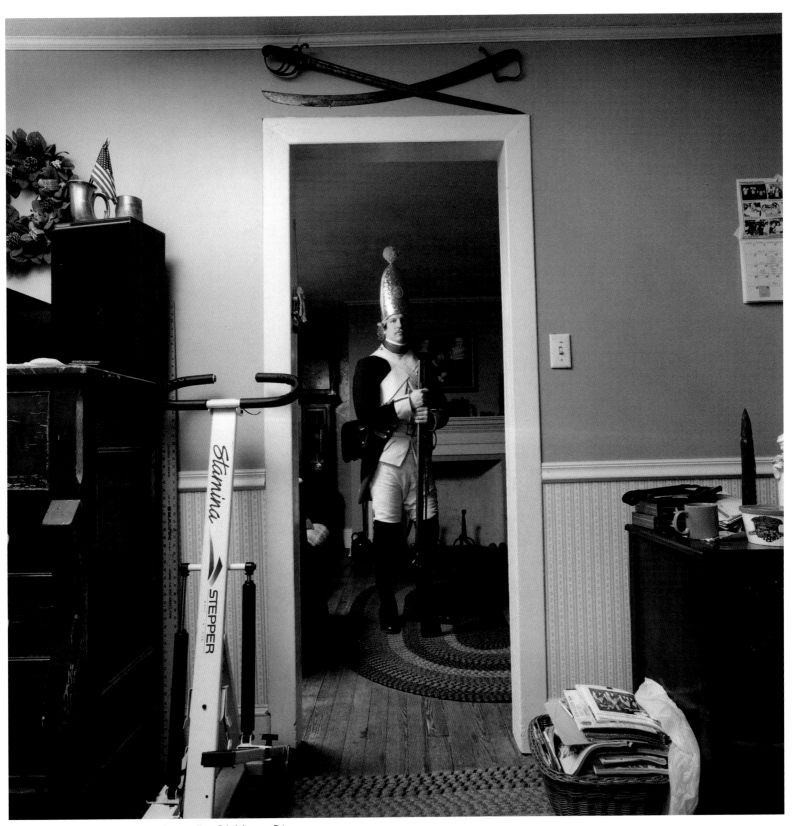

Todd Gerding as a Hessian Grenadier, Richboro, PA

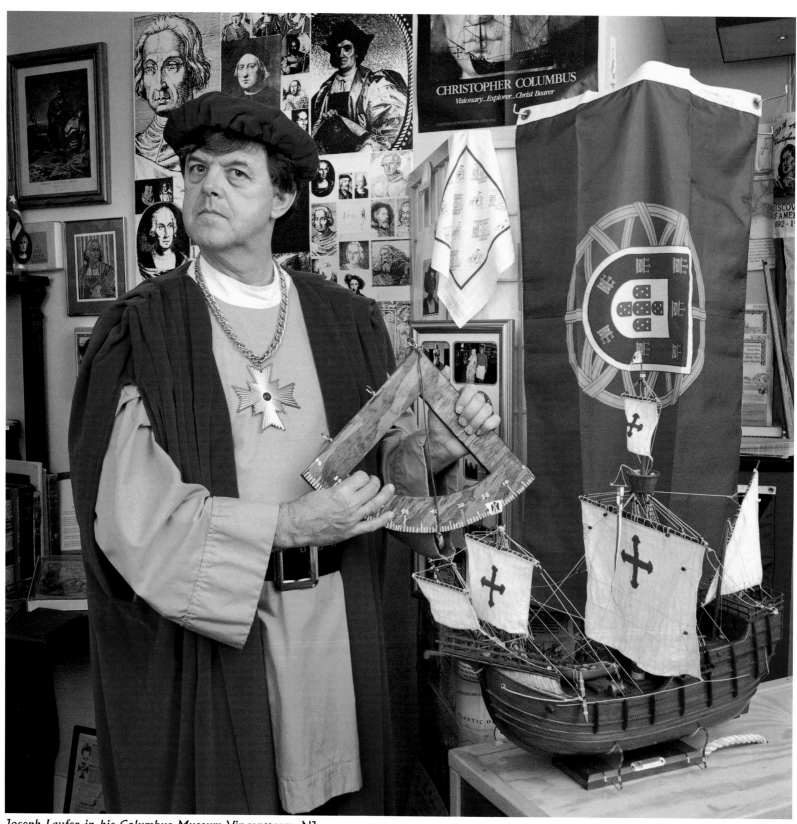

Joseph Laufer in his Columbus Museum, Vincenttown, NJ

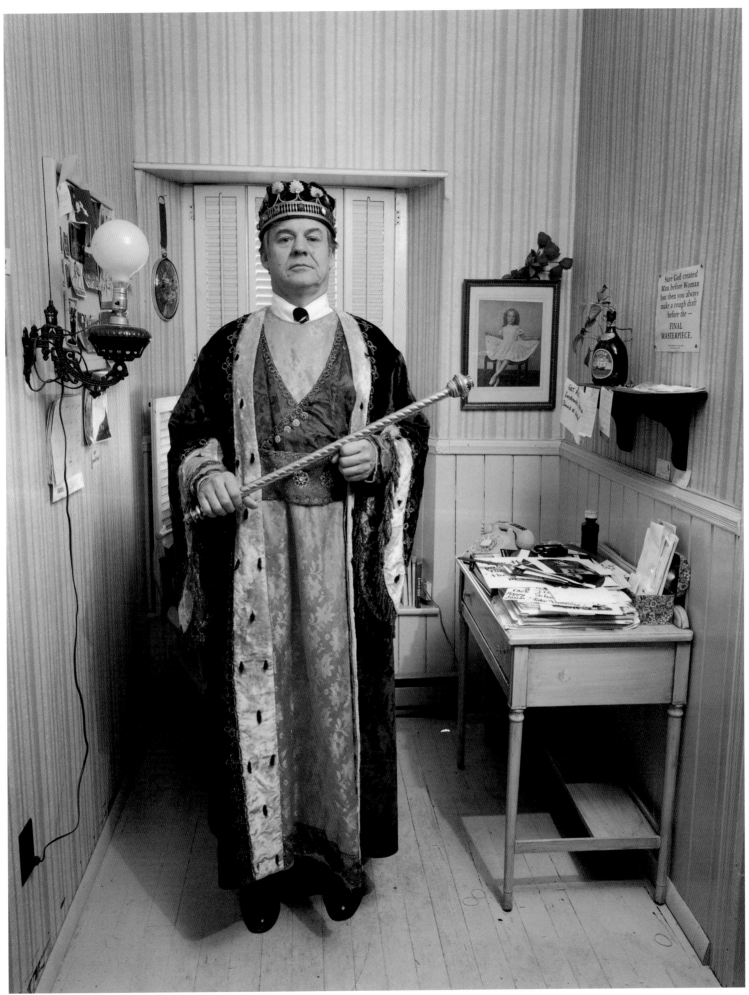

Henry Ford, Chancellor, Knights of Pythias, Newtown, PA

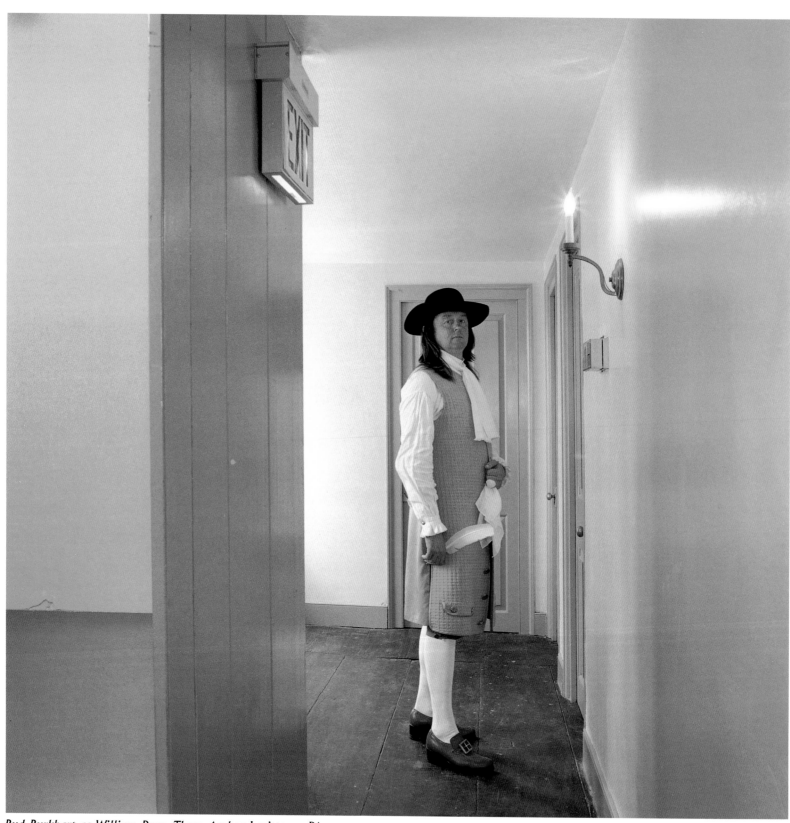

Bud Burkhart as William Penn, Three Arches, Levittown, PA

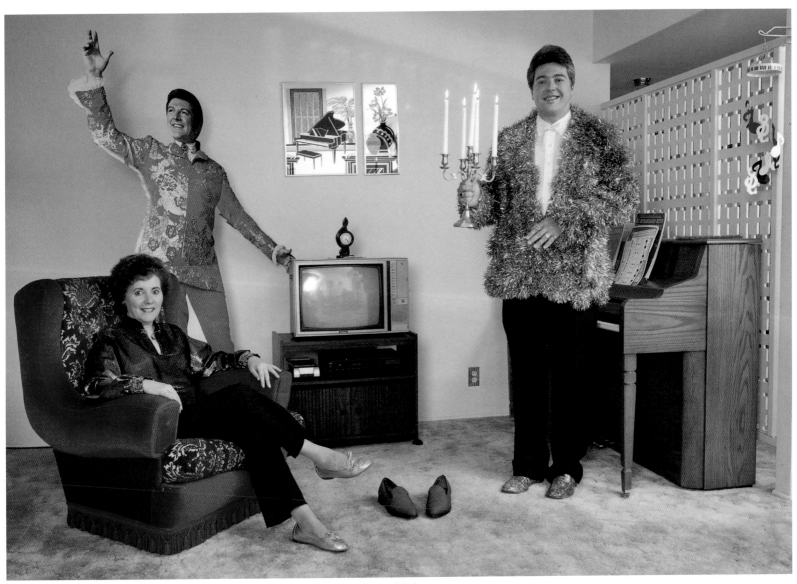

Paula LaChance and Gregory Milzeska with Liberace's Shoes, Las Vegas, NV

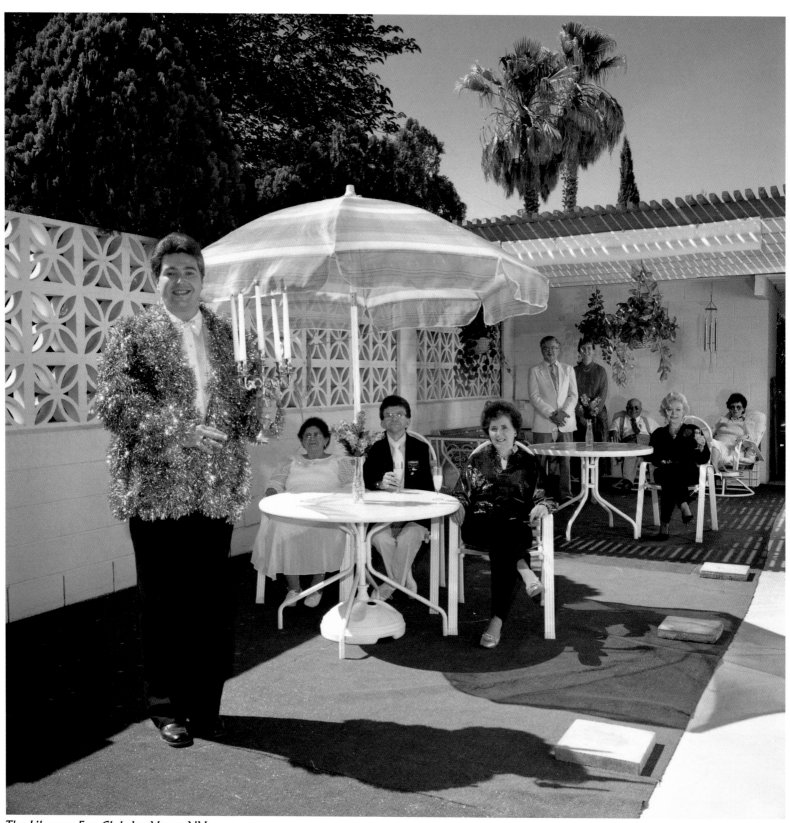

The Liberace Fan Club, Las Vegas, NV

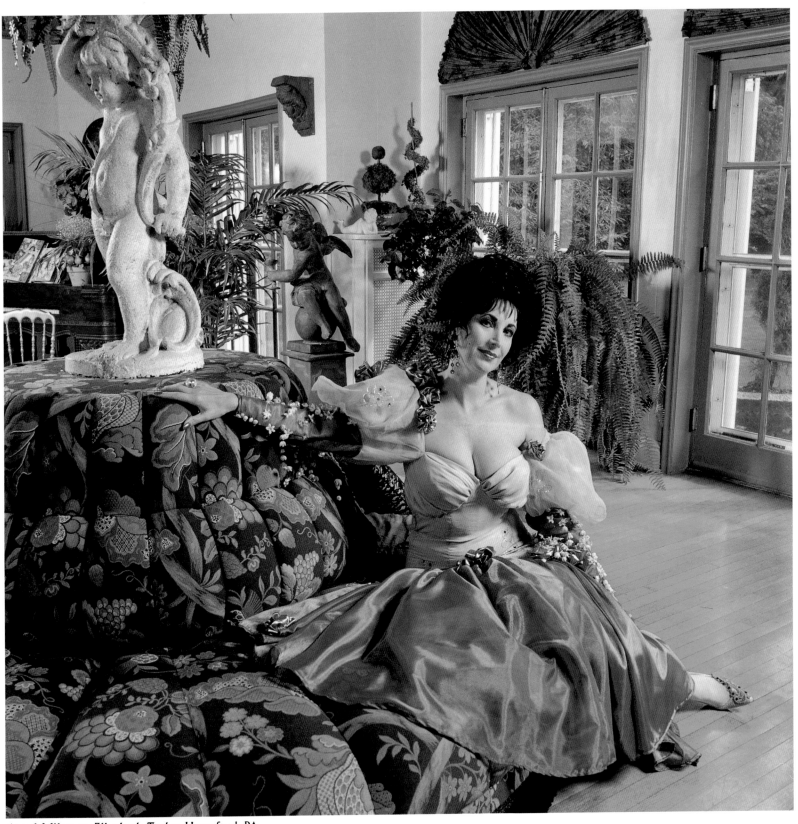

Angel Milou as Elizabeth Taylor, Haverford, PA

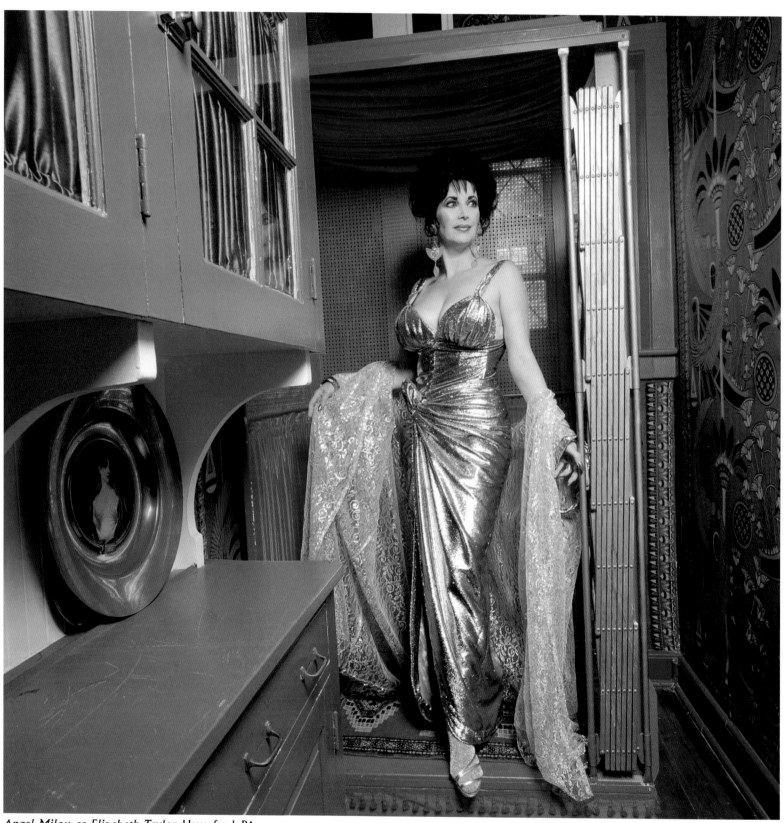

Angel Milou as Elizabeth Taylor, Haverford, PA

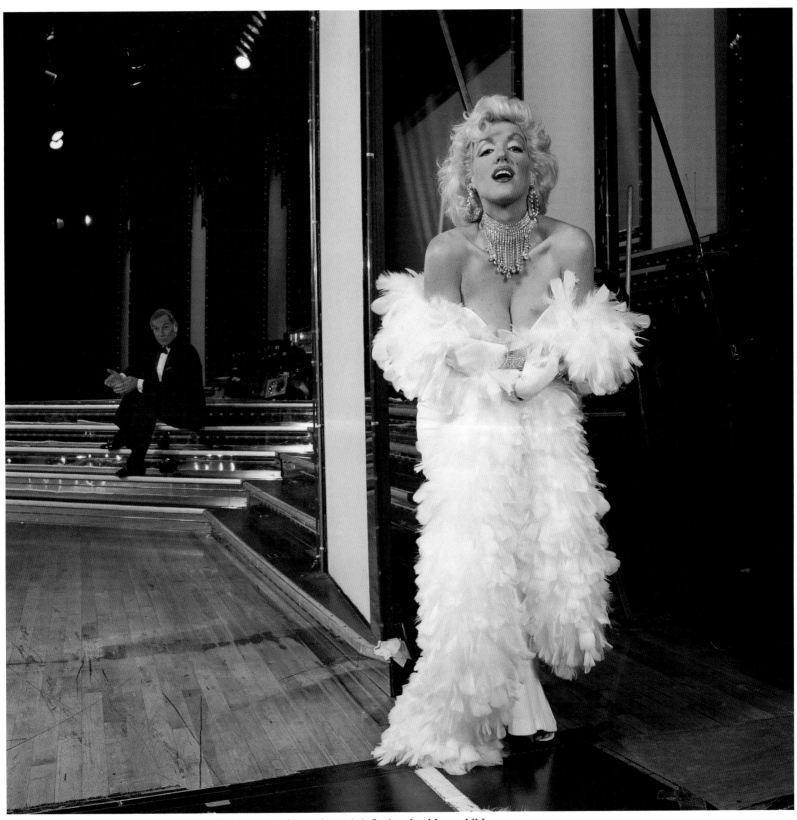

Sydney Revere as Marilyn Monroe in The Legends Show, Imperial Casino, Las Vegas, NV

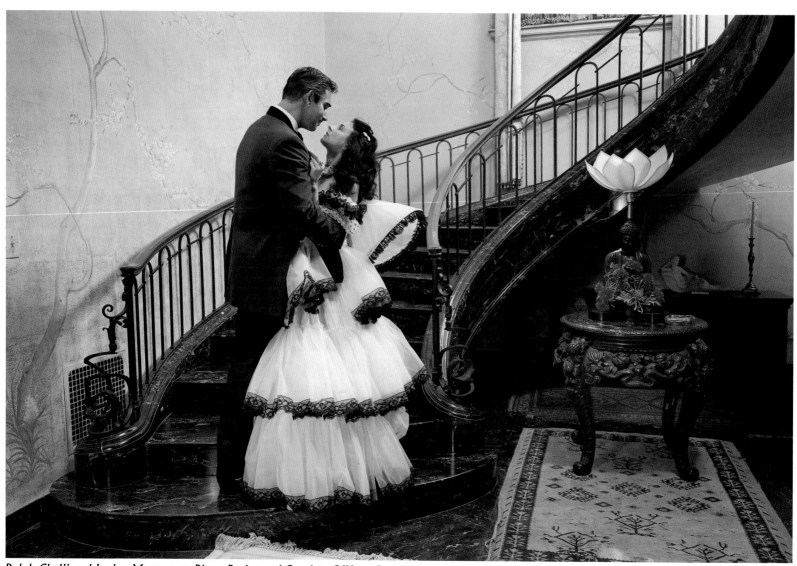

Ralph Chelli and Lesley Morgan as Rhett Butler and Scarlett O'Hara, Pasadena, CA

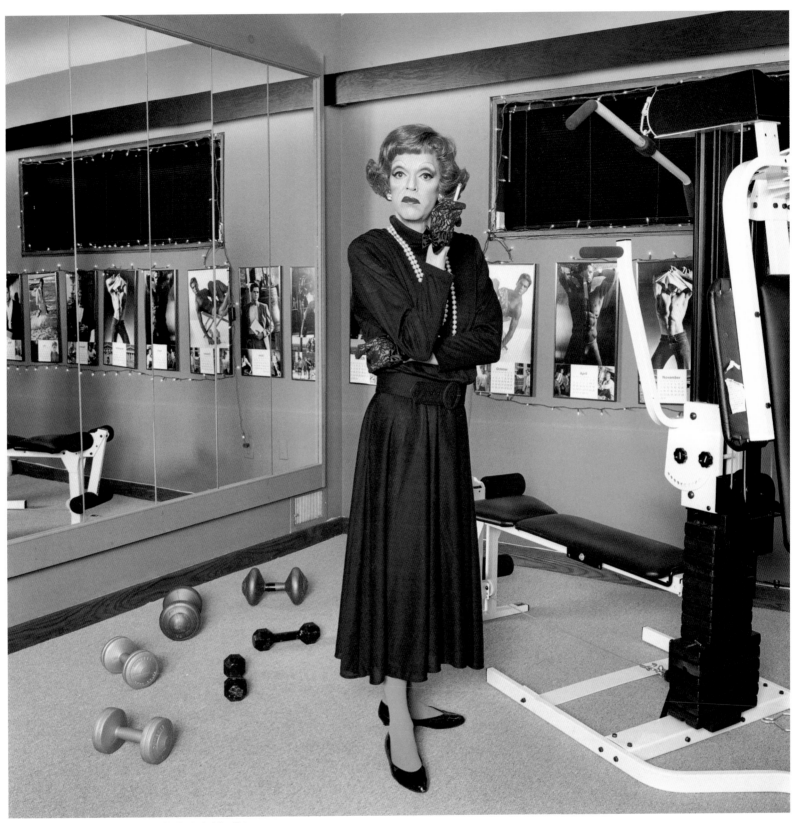

Randy Allen as Bette Davis, Philadelphia, PA

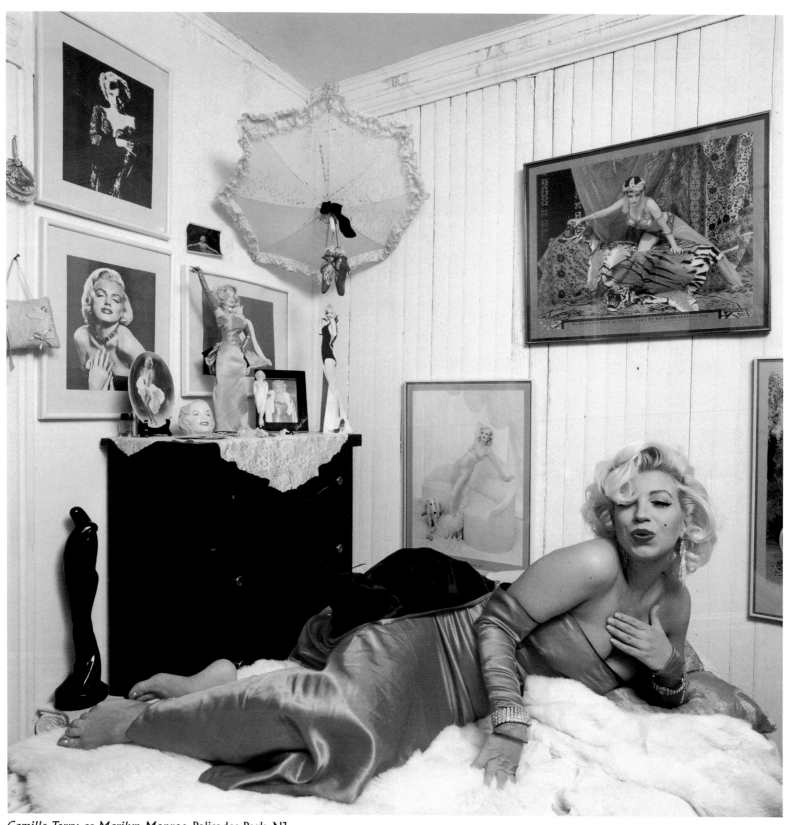

Camille Terry as Marilyn Monroe, Palisades Park, NJ

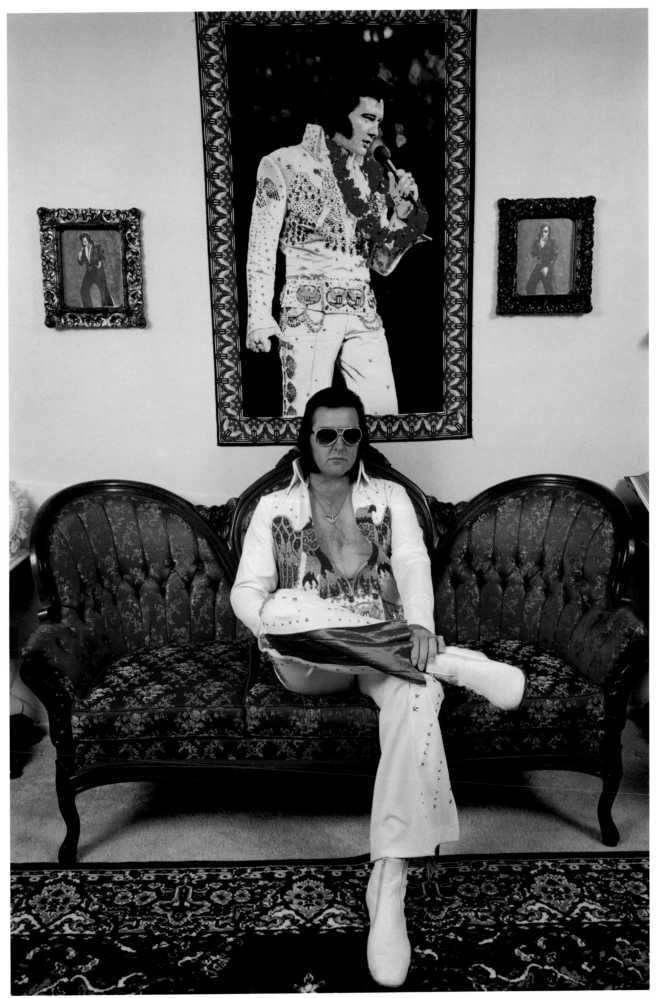

Steve Peri as Elvis, Ontario, CA

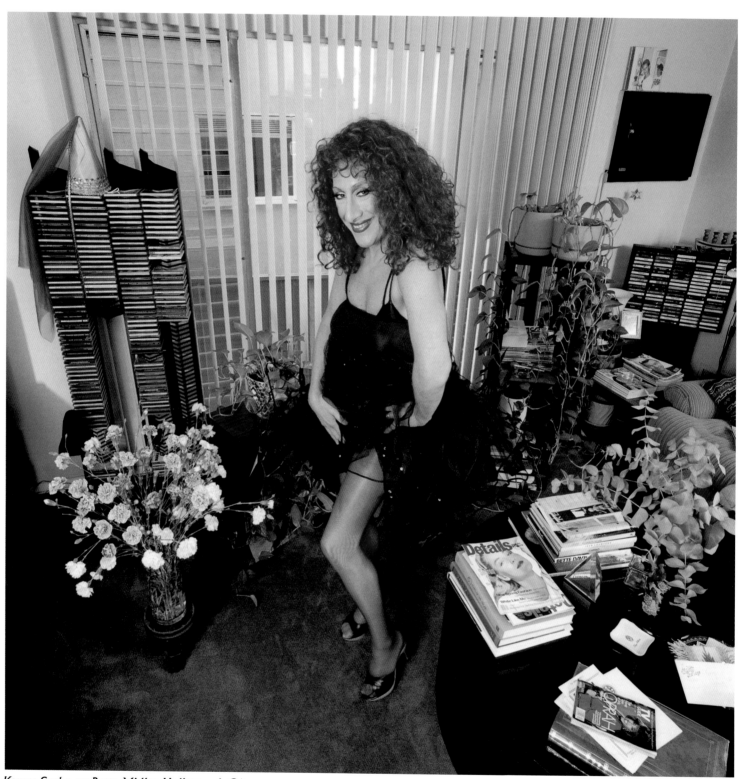

Kenny Sasha as Bette Midler, Hollywood, CA

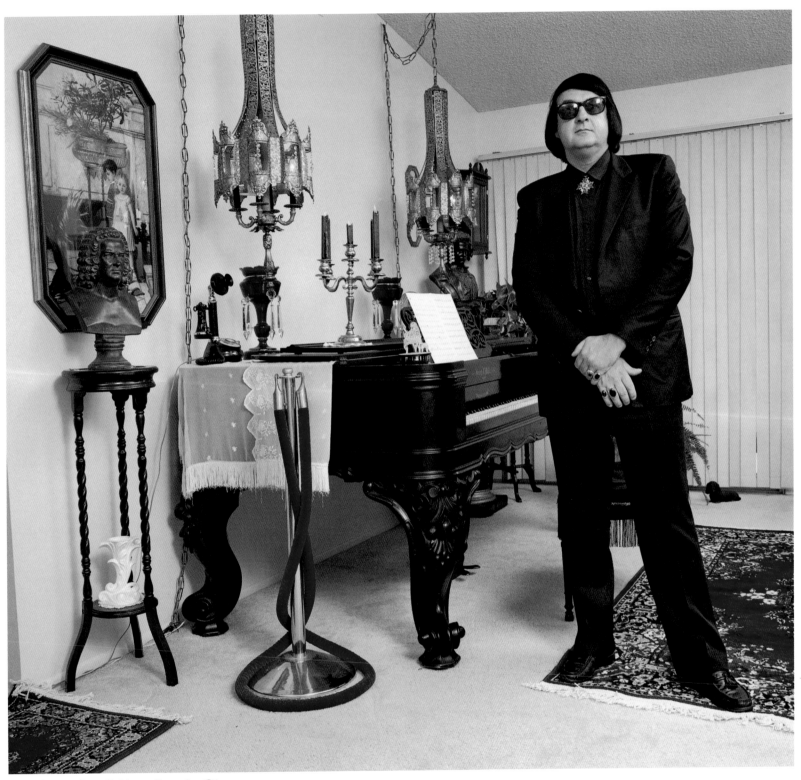

Terry Ray as Roy Orbison, Ontario, CA

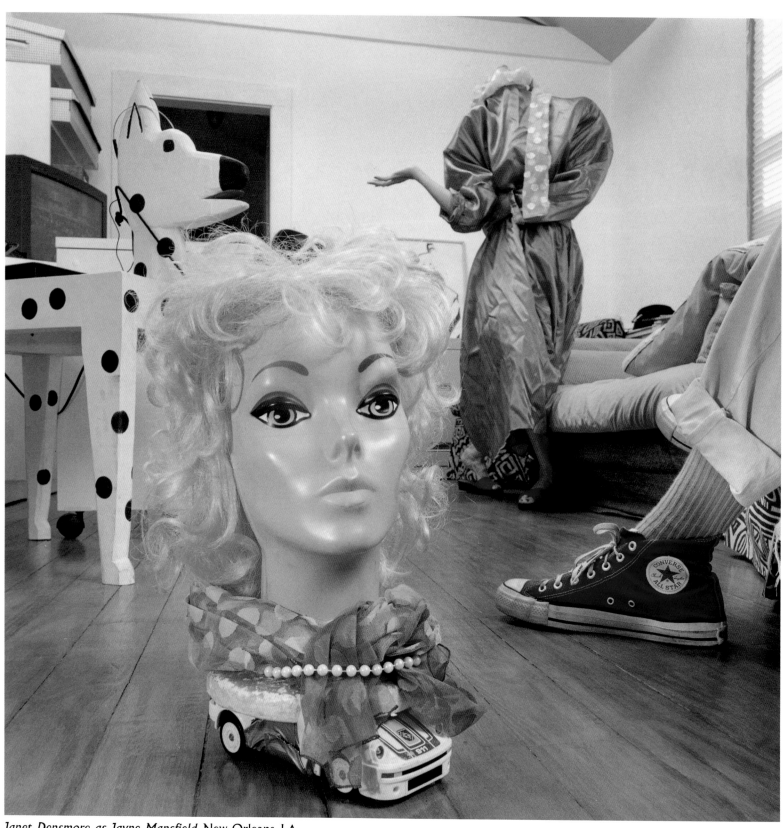

Janet Densmore as Jayne Mansfield, New Orleans, LA

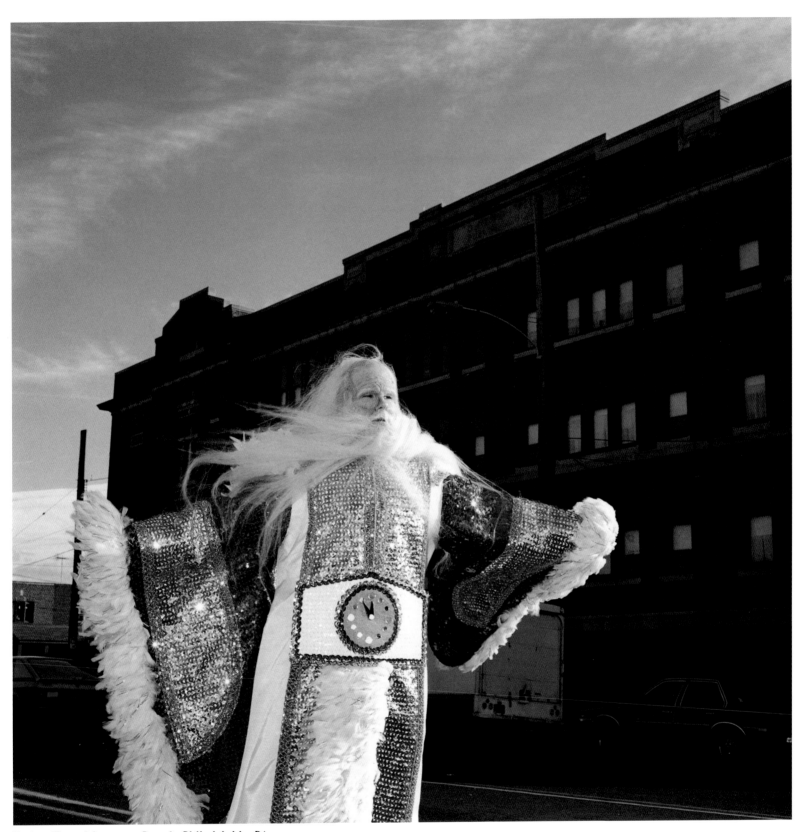

Father Time, Mummers Parade, Philadelphia, PA

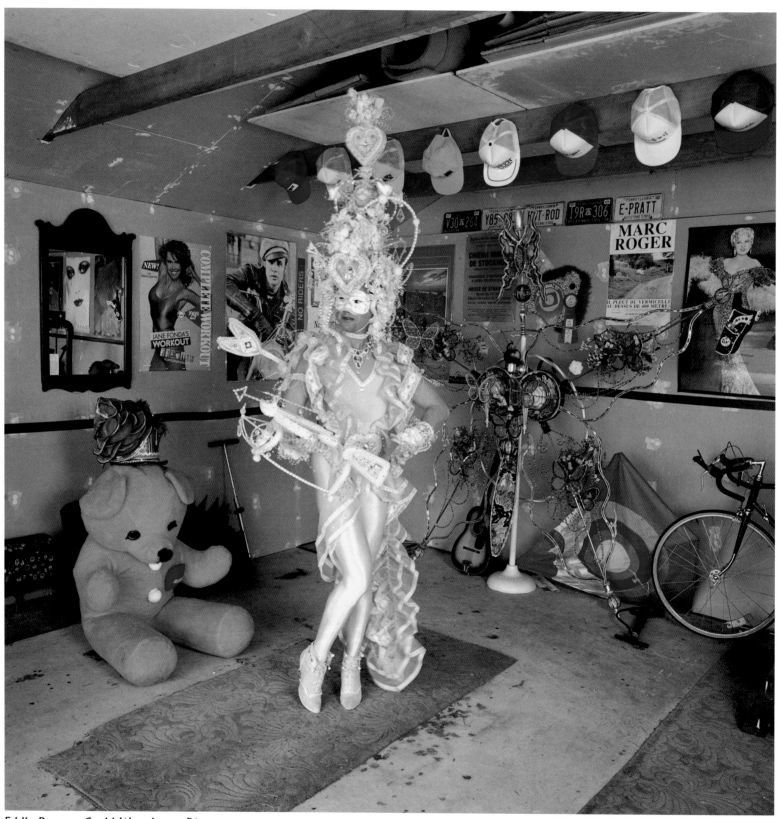

Eddie Pratt as Cupid, Warminster, PA

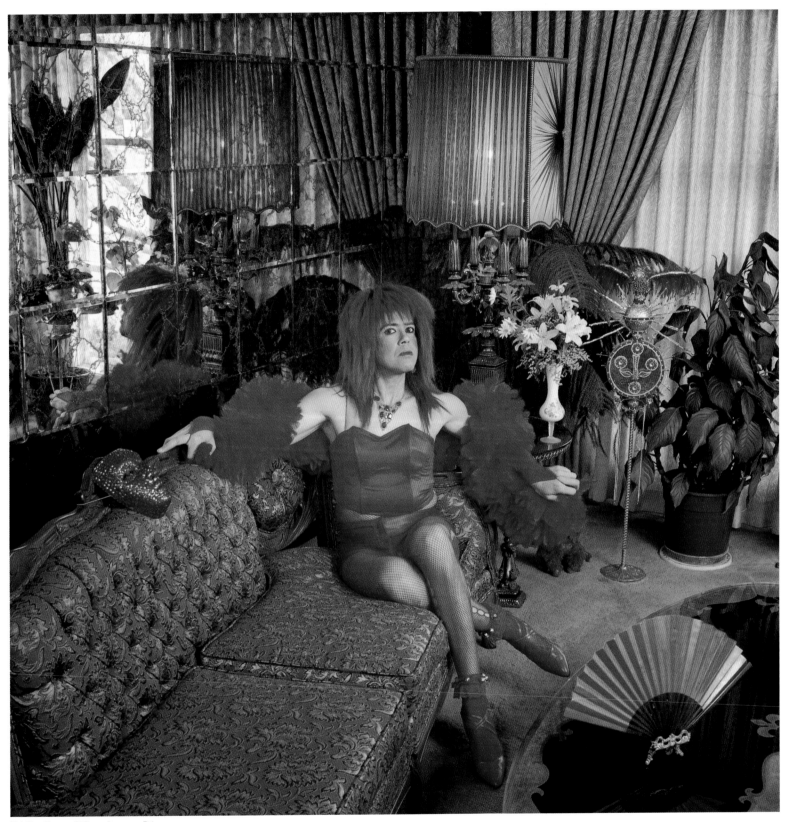

Eddie Pratt, Warminster, PA

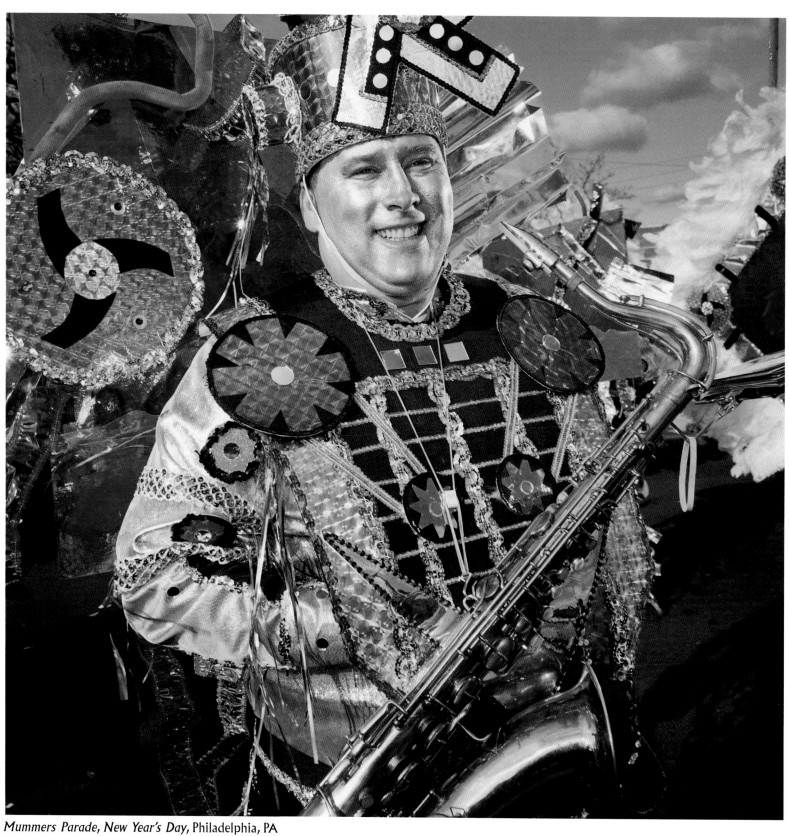

Mummers Parade, New Year's Day, Philadelphia, PA

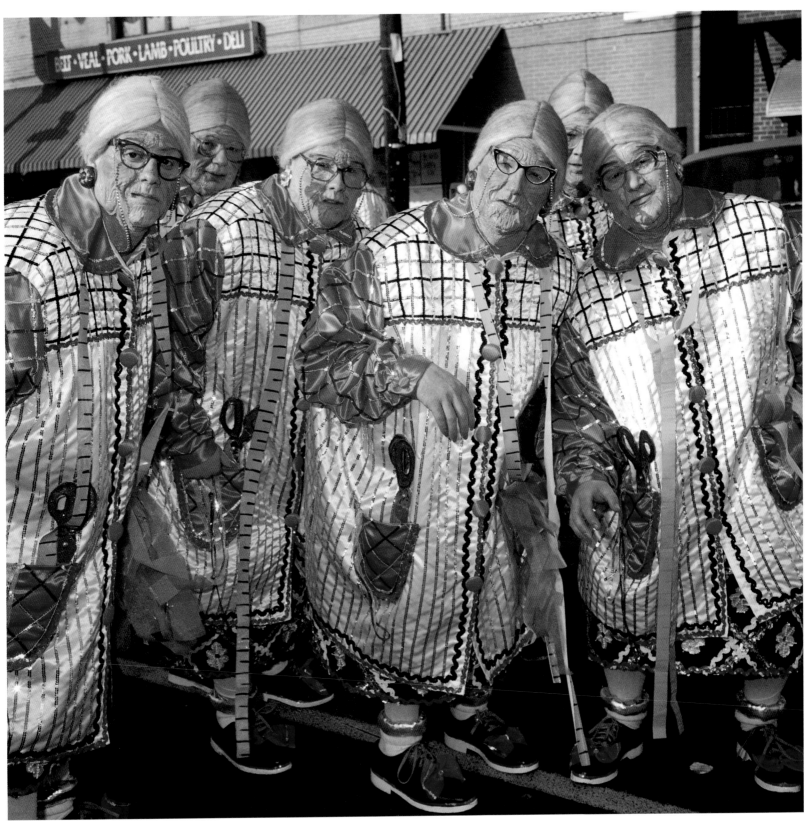

Mummers Parade, Philadelphia, PA

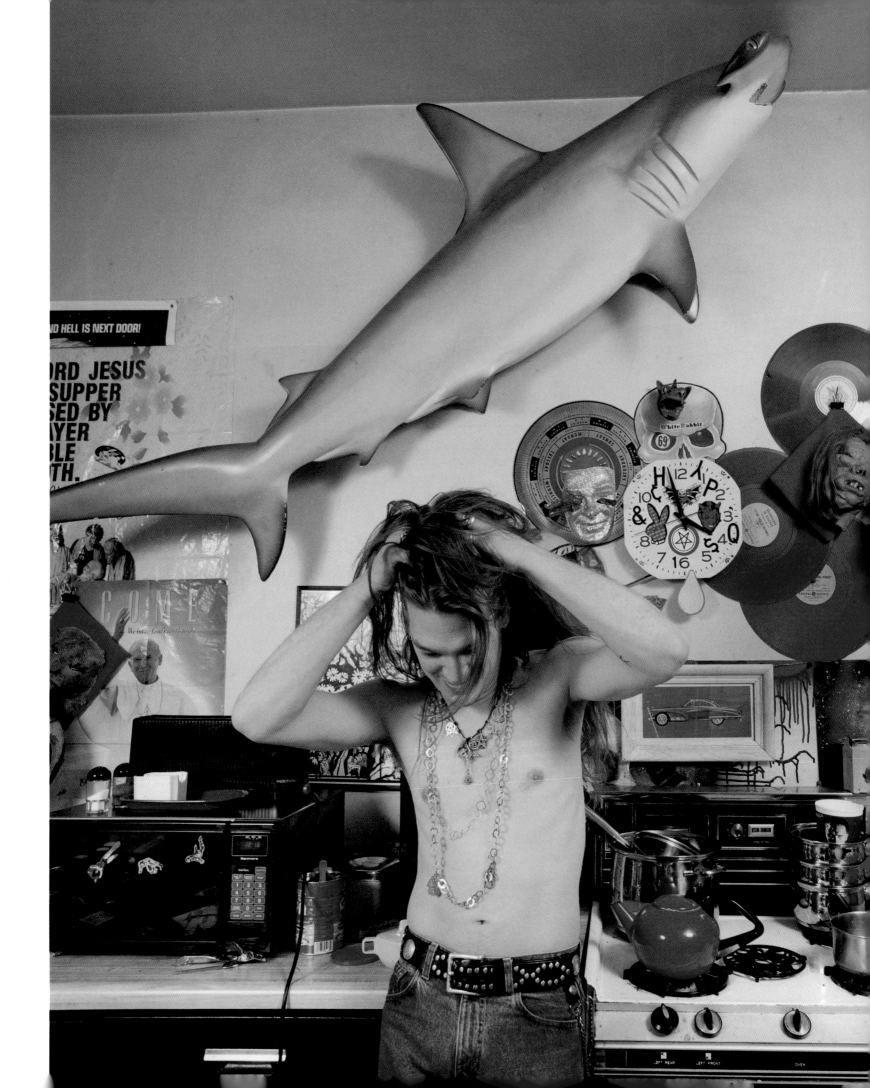

t home

At home, David Graham's Americans are no different than they are on stage. Their homes are stages. On the home-stage, unbound *Hee-Haw* surrealism has prevailed and flourished. The stuff they have! Never before, in the history of the world, have average people possessed such stuff. Multi-level stereos, fish tanks, stuffed chairs covered in blinding fabrics, life-sized dolls, manorial-sized lawns, televisions, rocking chairs, welcome mats, brass beds! Amid these lakes of objects derived by channeling from the great rivers of shopping malls and flea markets stand brides, beauty queens, and Scottish marshals. The overflow has also caused illness. A young woman, allergic to everything, huddles in the middle of a white bed in an all-white room with a black bible next to her. With her, we arrive at the other shore of unbound materialism. She has a bad case of "too much" and has withdrawn her body from the great river. Her mind is seeking the desert. In that desert there is only one Book. Equally withdrawn but anchored to his faith is an overweight and clearly depressed man sitting on a brass bed with a garish lithograph of Jesus above him. These two images may appear to be rare glimpses of cracks in David Graham's relentlessly ironic refusal of judgment, but, in the end, these unfortunates are self-made, still tied to the material world by their fear of it.

"Home" and what that means to Americans is a subject David never tires of. In a splendid view of a suburban dwelling, three generations tend to their home in different ways. The youngest is on a ladder, painting; the middle one and, no doubt, the current breadwinner, is standing in the doorway in his Bud cap, either surveying the property or calculating the costs of the renovation; the eldest sits in his chair frowning at the world and daring it, just daring it, to come any closer. An American flag, temporarily displaced by the repairs, leans behind him in the bushes. And this house, they all say, is what we fought, fight, and will fight for. Onward, Christian soldiers!

Frankie Nardiello, Chicago, IL

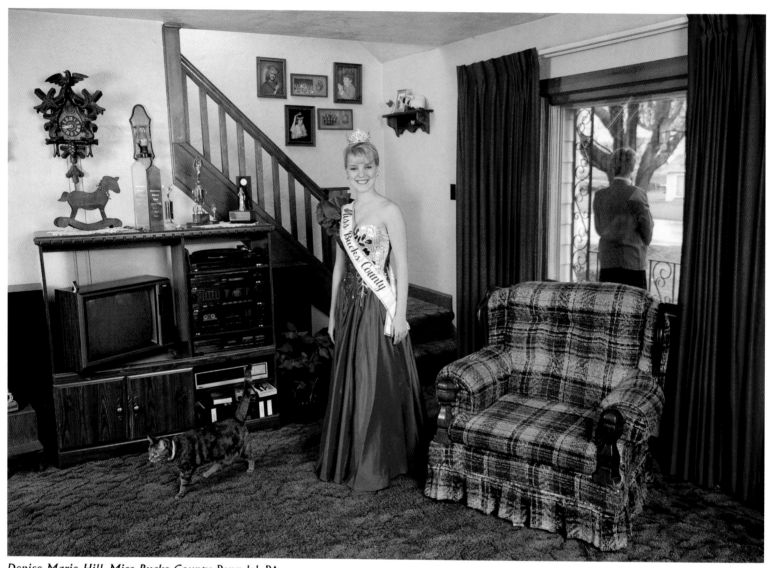

Denise Marie Hill, Miss Bucks County, Penndel, PA

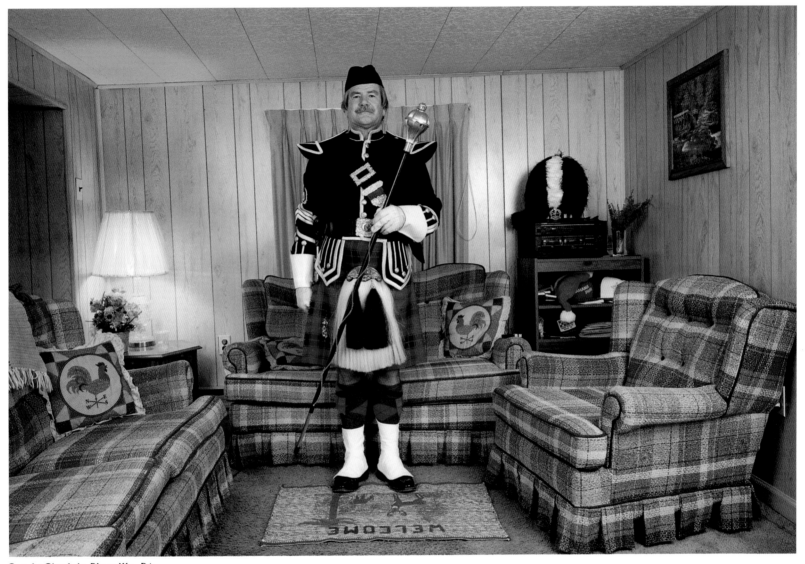

Sandy Sinclair, Pineville, PA

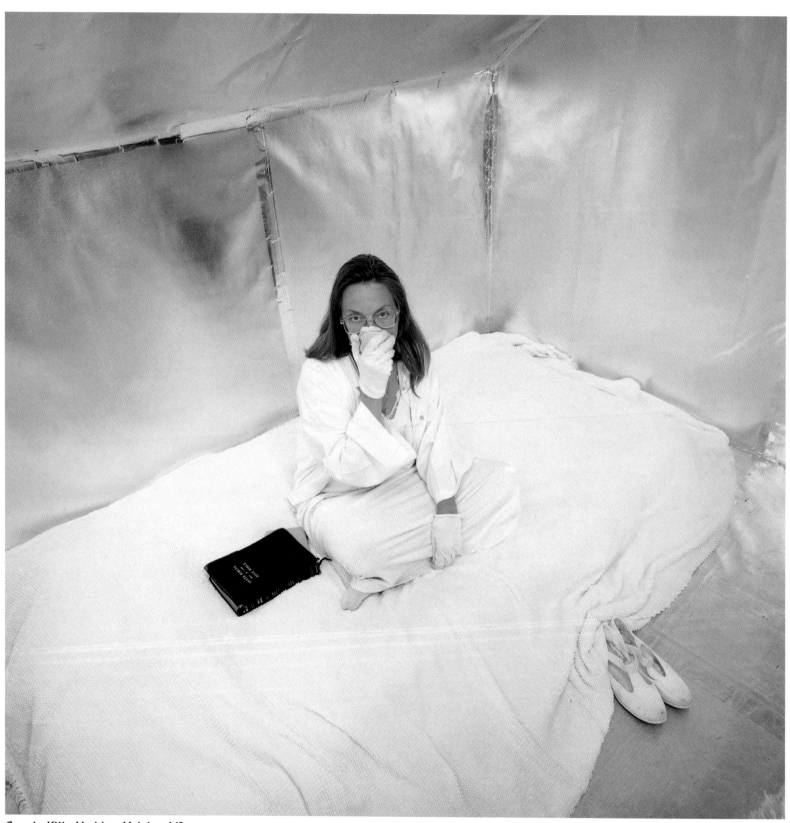

Connie Kille, Haddon Heights, NJ

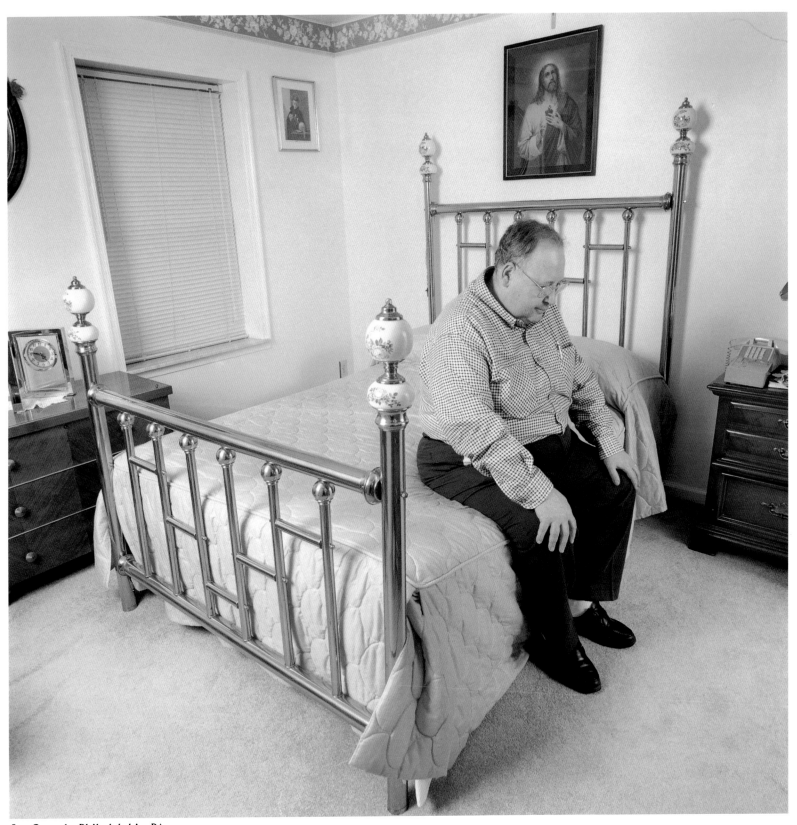

Joe Scavola, Philadelphia, PA

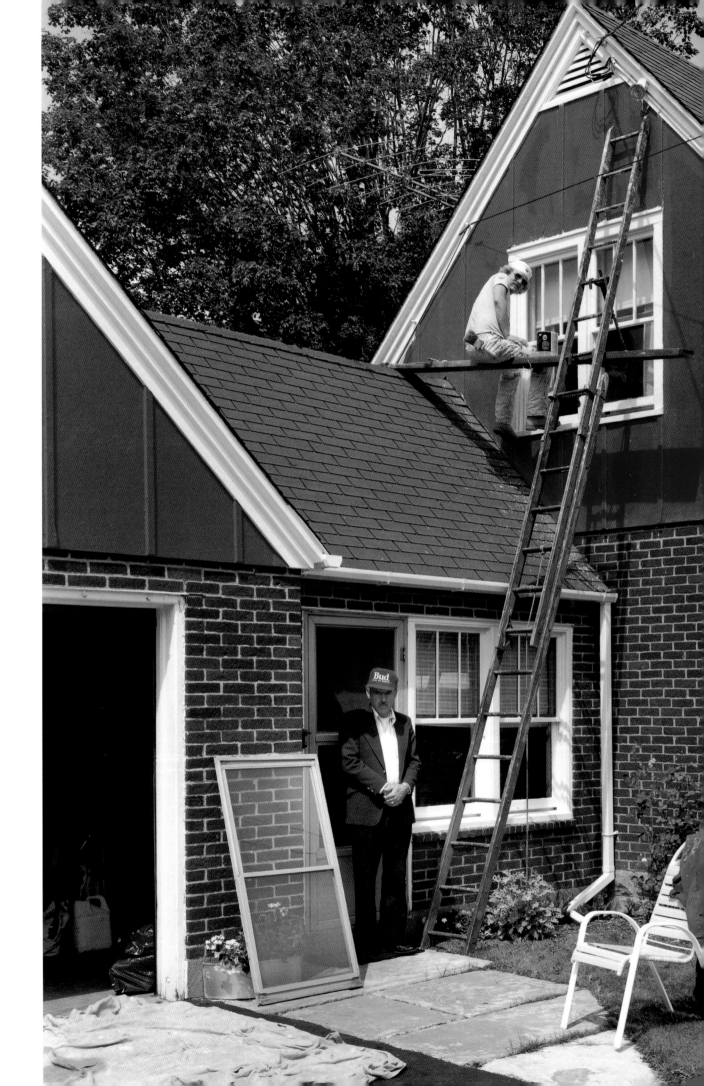

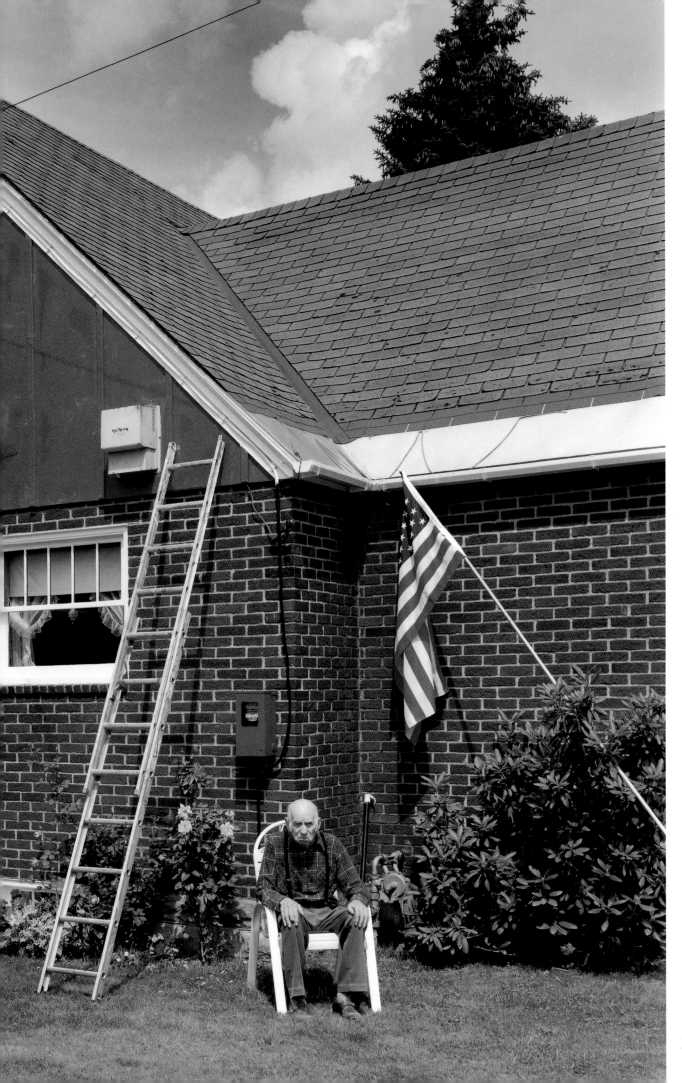

Near Niagara Falls, NY

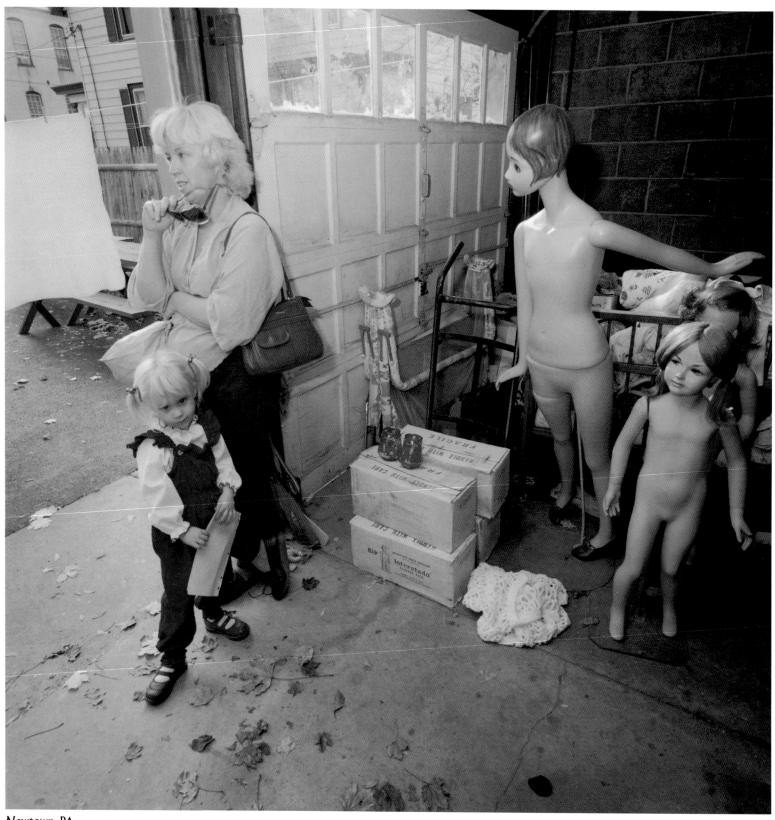

Newtown, PA

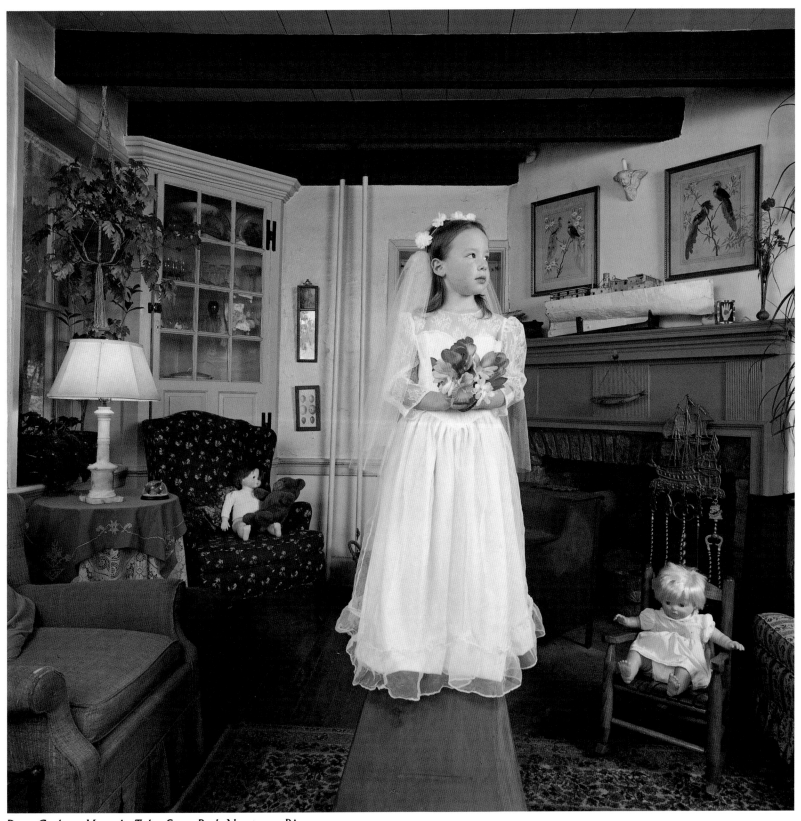

Dory Graham–Vannais, Tyler State Park, Newtown, PA

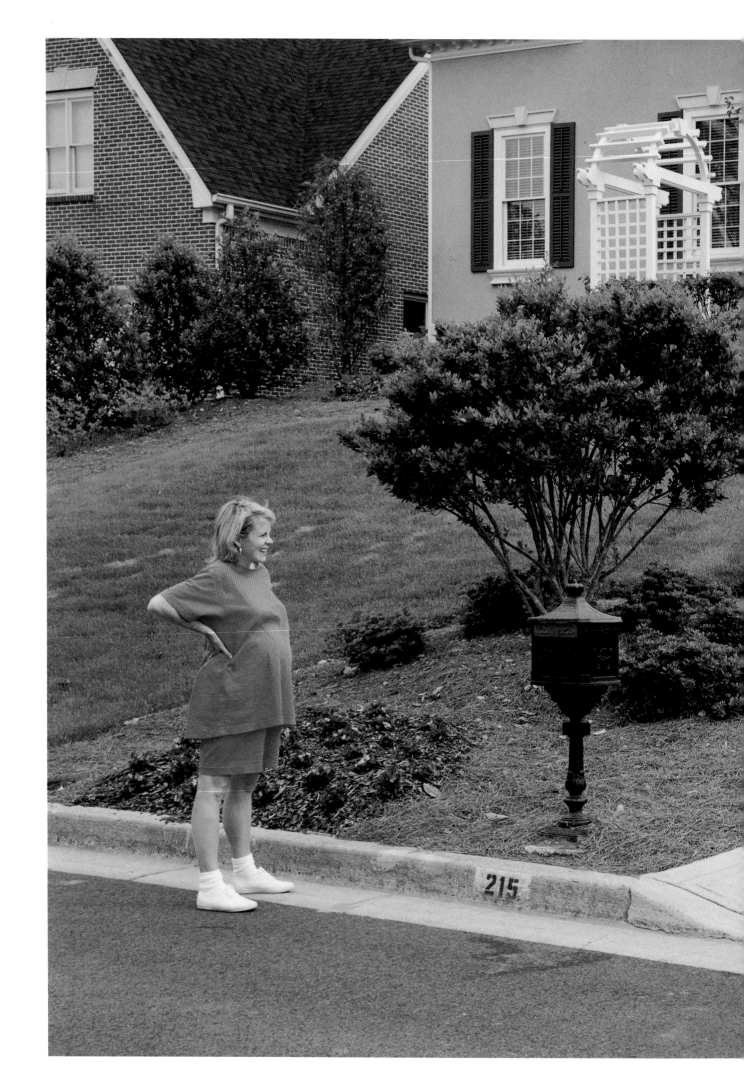

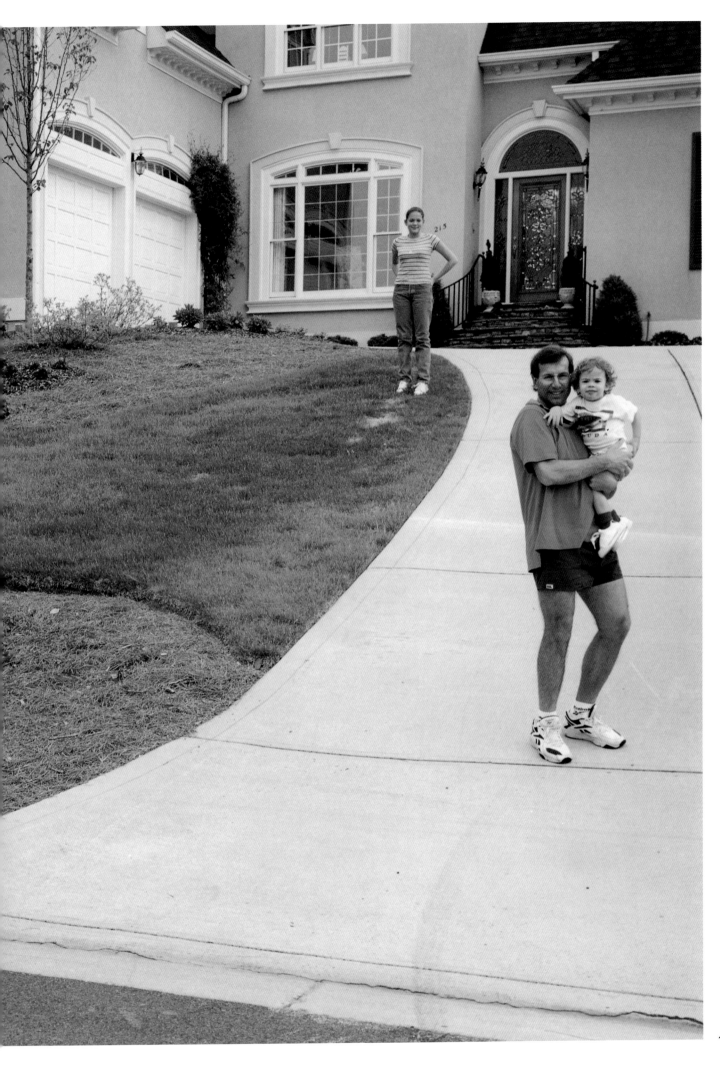

Atlanta, GA

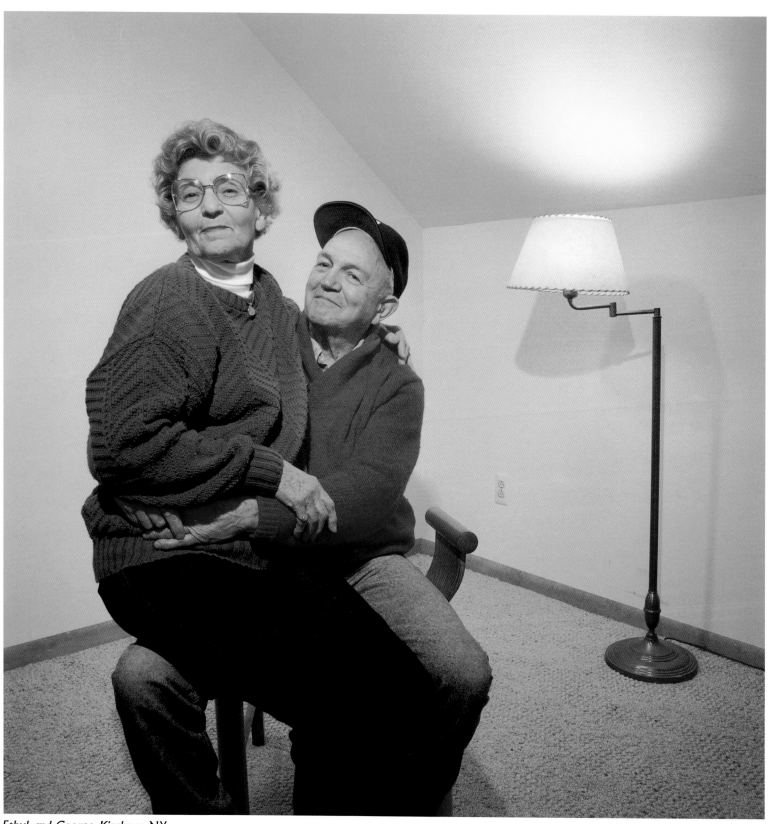

Ethyl and George Kirshner, NY

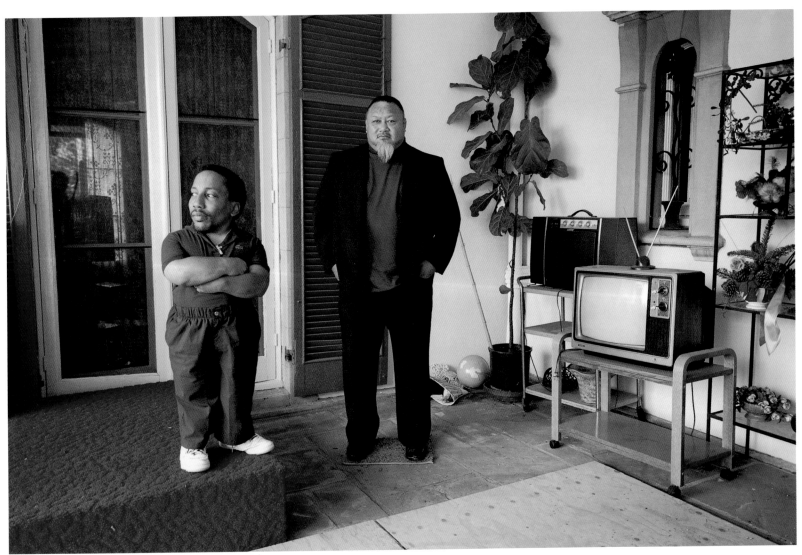

Tyen and Professor Tooaaka, (Odd Job), Pasadena, CA

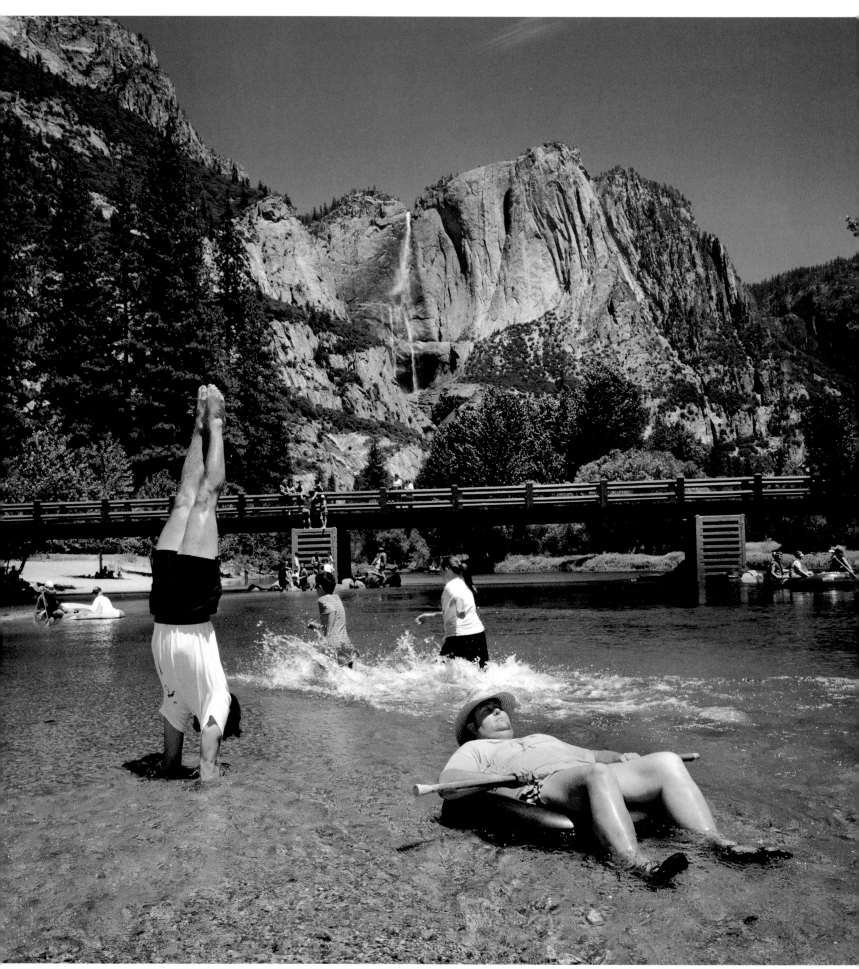

Yosemite National Park, CA

The great outdoors

"Recreation Wrecks the Nation" reads a bumper sticker authored by the poet Ed Dorn. Americans on vacation could care less. They live in the outdoors exactly the way they do at home, only less carefully. They are utterly unselfconscious about their bodies, about who might be watching, or about what might attack them. It's their country, and they don't care who knows it. A guy in sunglasses is paddling without a boat in the middle of a beautiful river, looking defiantly into the wilderness. Three guys arrayed like gunless gunfighters are walking on water. A cosmically willful old hippie leans on an ocotillo fence in New Mexico, the scene filled with sky and mountain and the smell of sage. A woman standing in tall grass points to some invisible danger in the distance. It could be an incoming storm or a bevy of illegal immigrants. It happens that she is at the former Branch Davidian site in Waco, Texas. Old women in a swimming class flock into the picture like happy birds. Fit old men in some elderly paradise are prepared to dive into a pool and break a record.

David Graham has traveled everywhere in this country, never taking his eyes off the way we behave, but he is at his most charming ease in the great outdoors. American landscapes are so spectacular, our nature is so rich, varied and wild, that people have no need for masks. Indeed, amid rivers, lakes, mountains, and sky, masks would be superfluous. At home or at their weird jobs, David's subjects feel that they must be more than they are, that they must flaunt their freedom by acting out. But in Point Breeze or Ocean City, dissimulation is unnecessary, though a certain stubbornness and work ethic remains. Exercise and classes are as necessary to Americans' self-image as success in the workplace. The energy that drives us to exaggerate, to flaunt, and to startle is also a drive for self-improvement. In their ironic but gentle way, David Graham's views of Americans are rooted in the Puritan ethic. One can sense, though barely, a faint dismay at the rate with which we discard our own productions in order to move on.

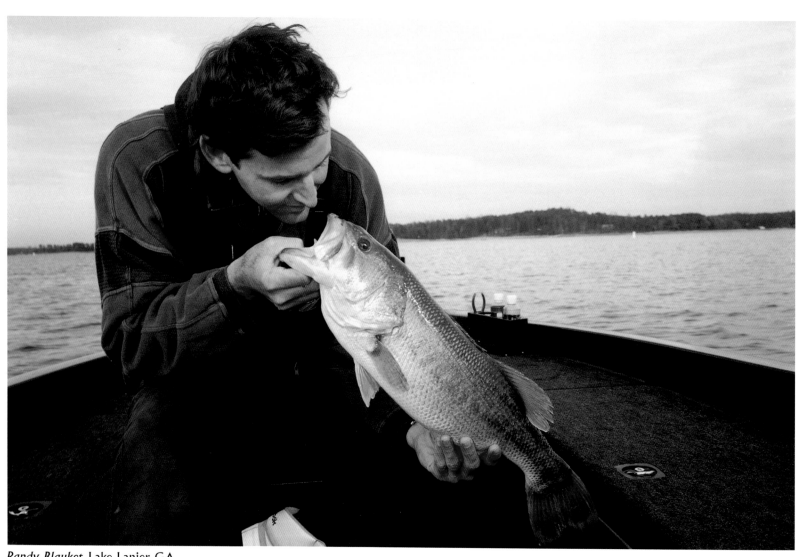

Randy Blauket, Lake Lanier, GA

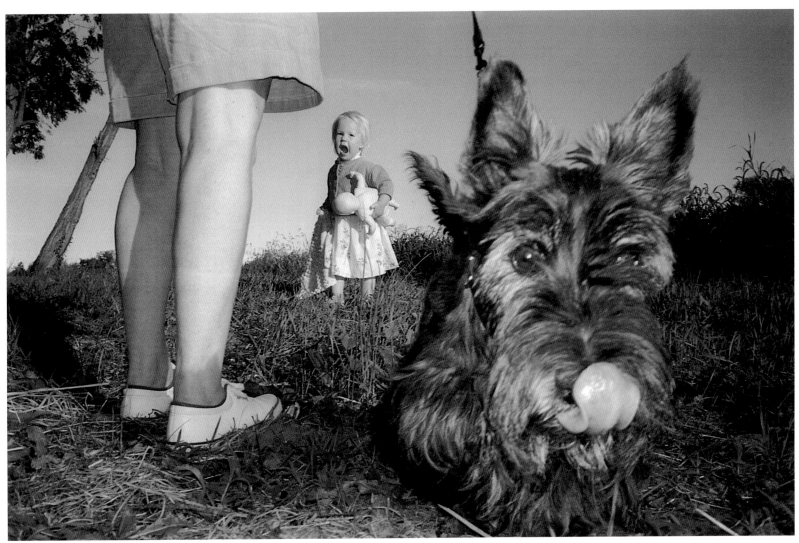

Xina Graham–Vannais, Tyler State Park, Newtown, PA

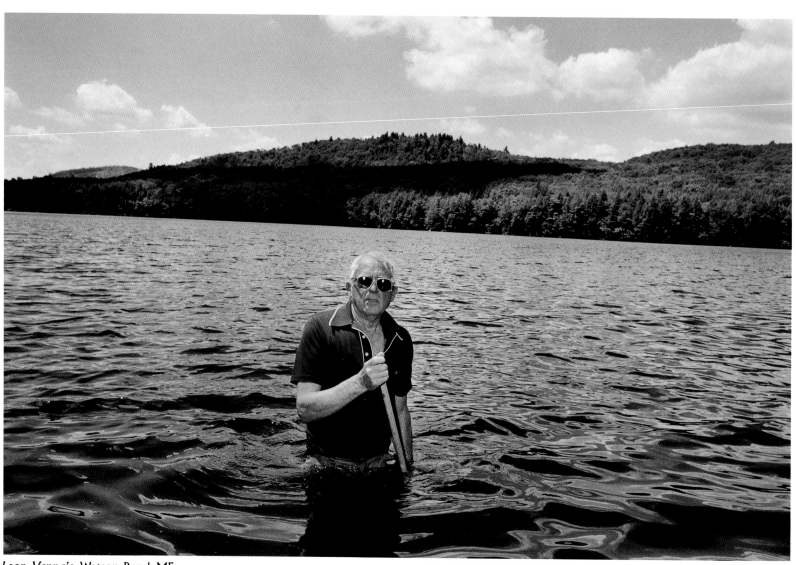

Leon Vannais, Watson Pond, ME

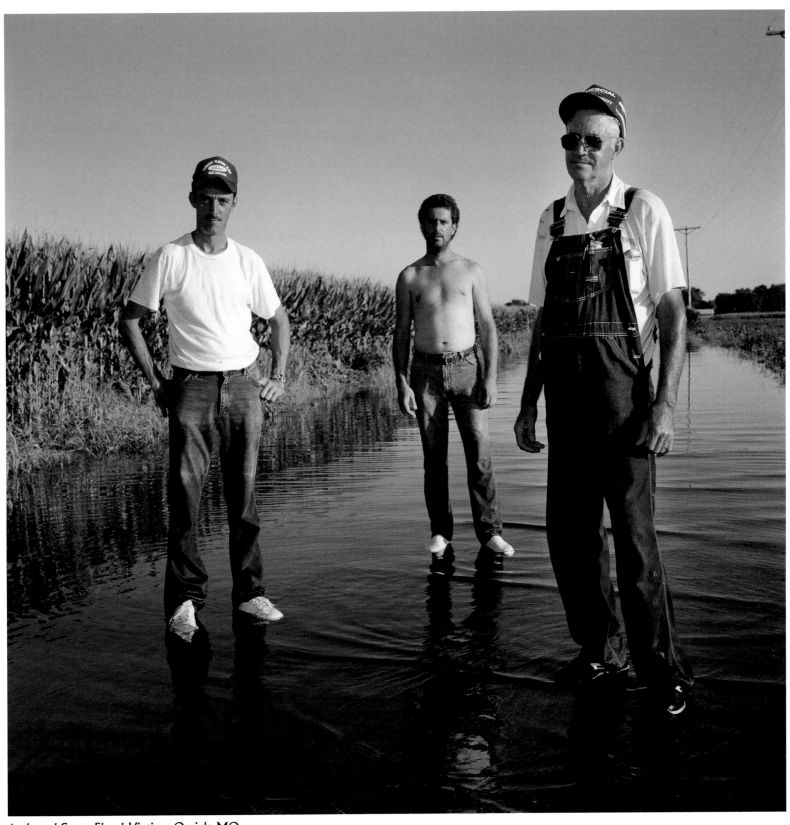

Arch and Sons, Flood Victims, Orrick, MO

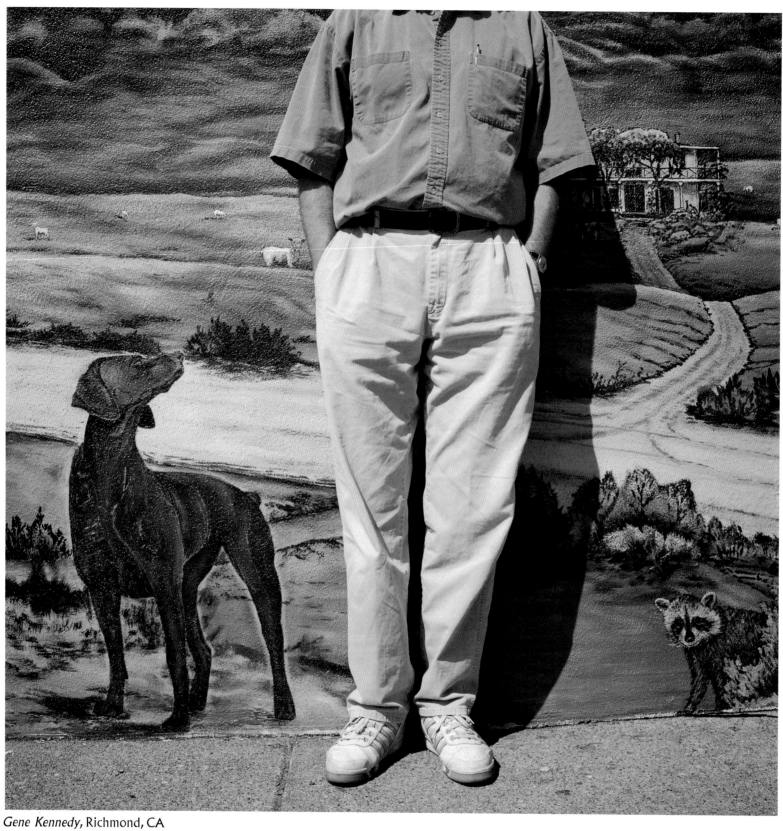

Gene Kennedy, Richmond, CA

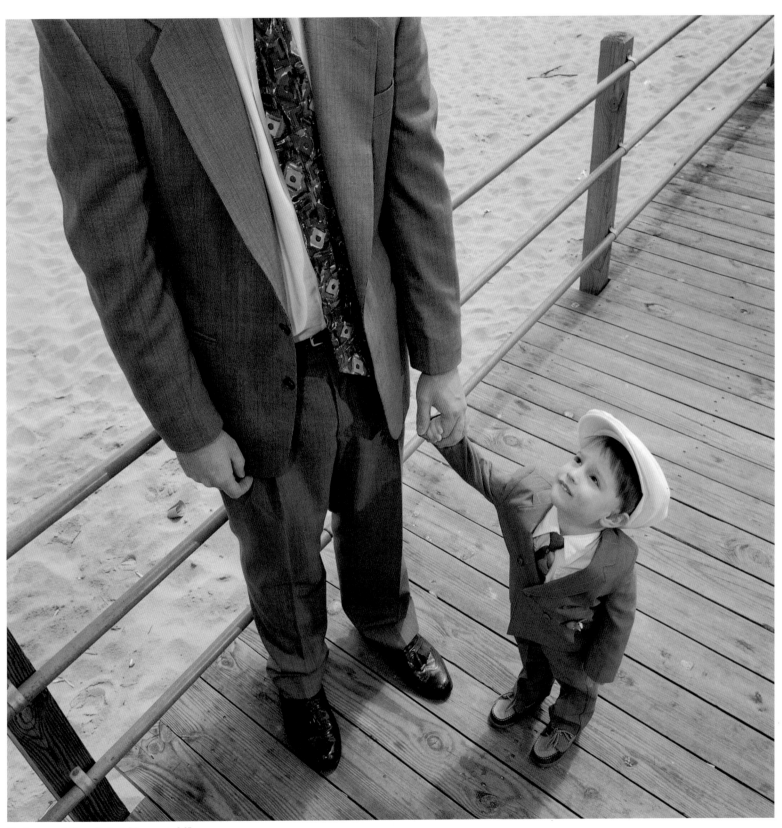

Father and Son, Point Pleasant, NJ

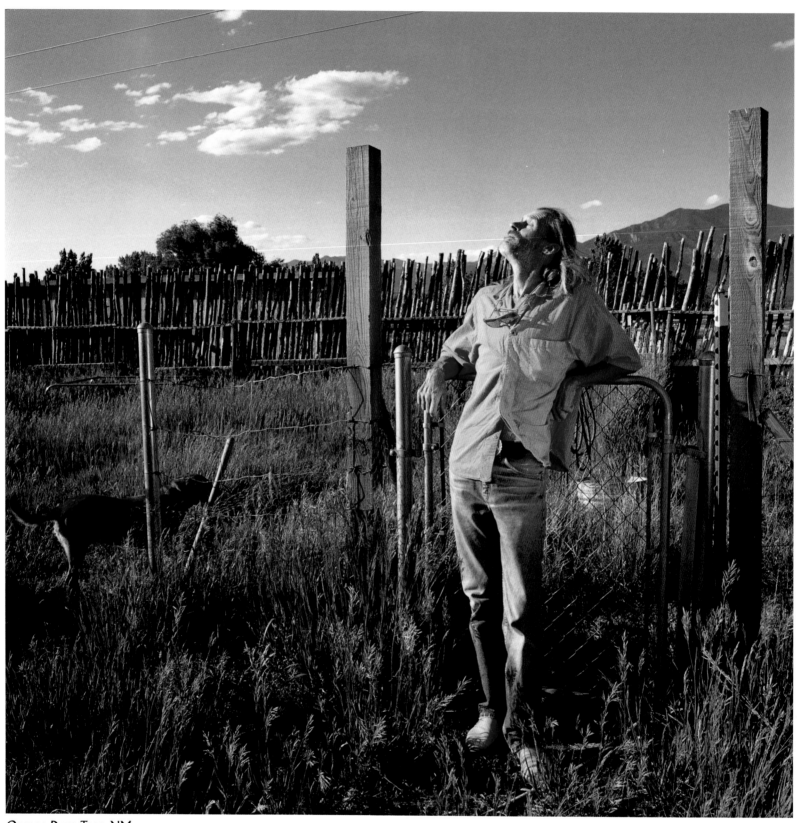

Orange Dave, Taos, NM

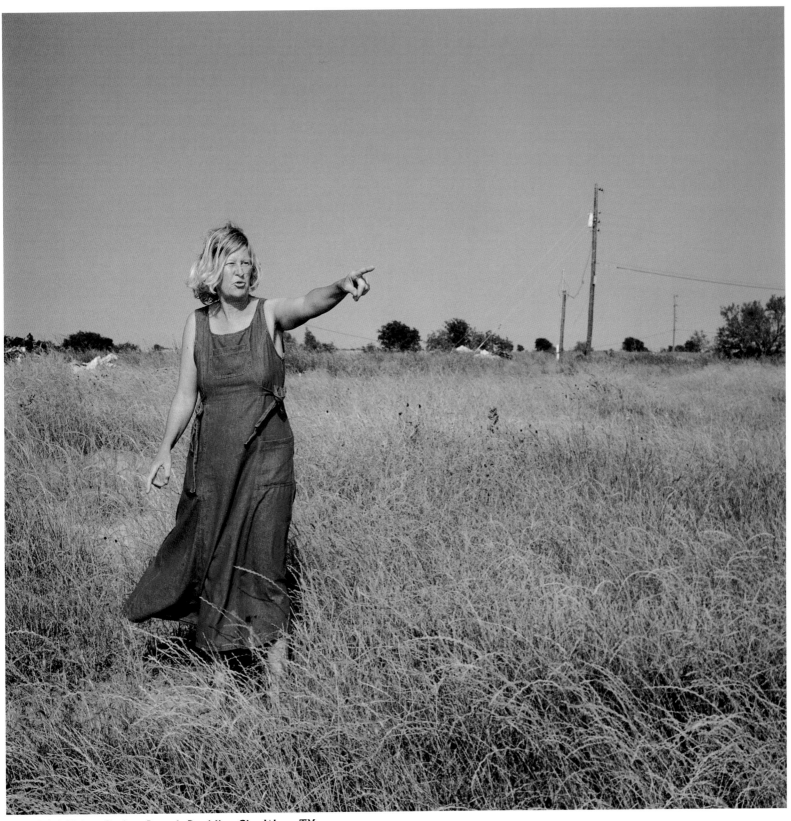

Amo Paul Bishop Roden, Branch Davidian Site, Waco, TX

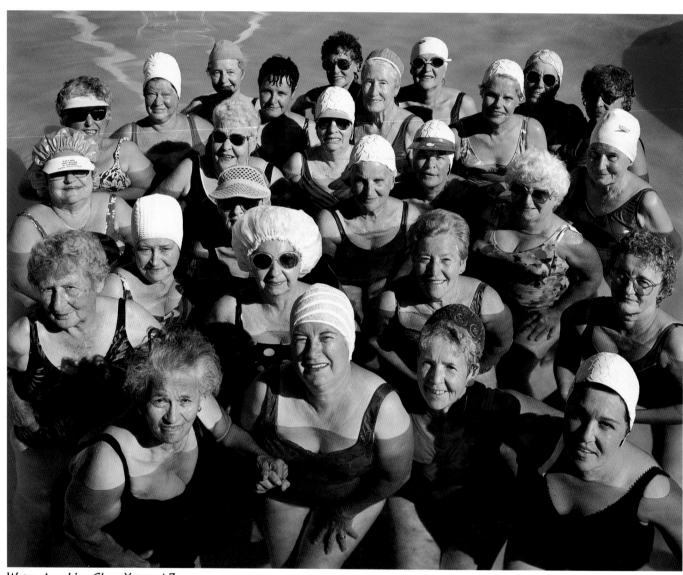

Water Aerobics Class, Yuma, AZ

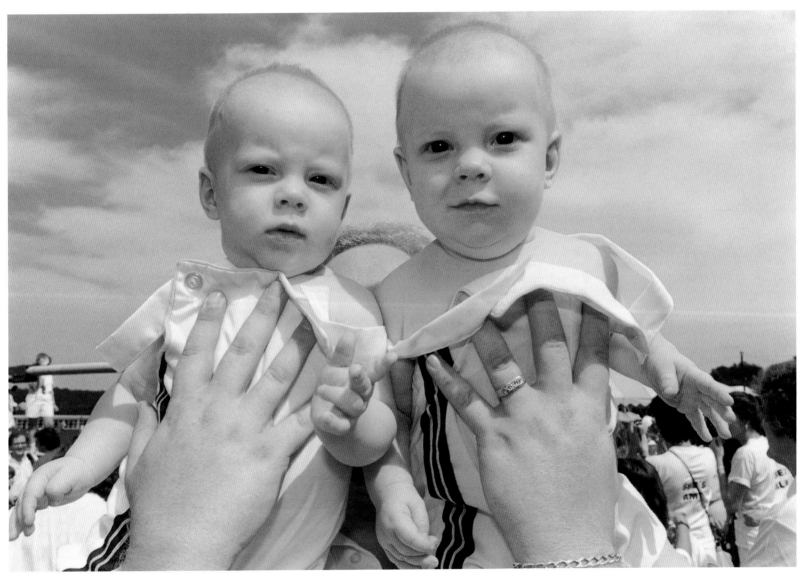

Twins Day, Twinsburg, OH

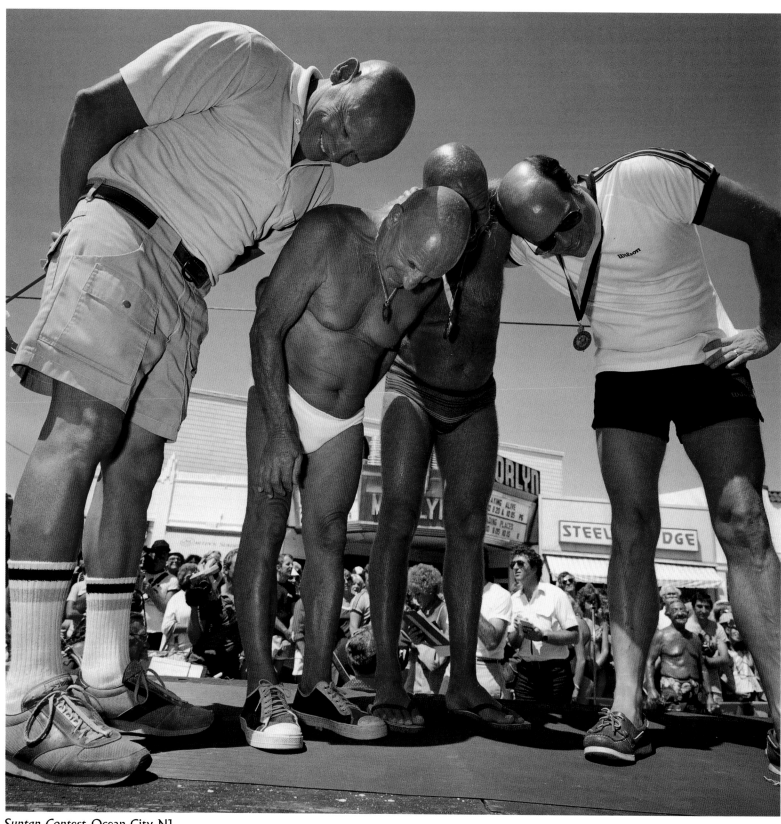

Suntan Contest, Ocean City, NJ

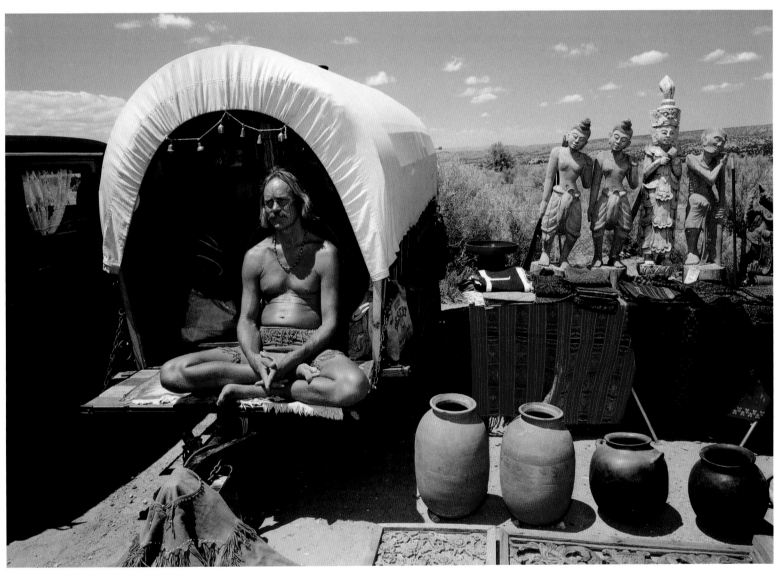

Santa Fe Flea Market, NM

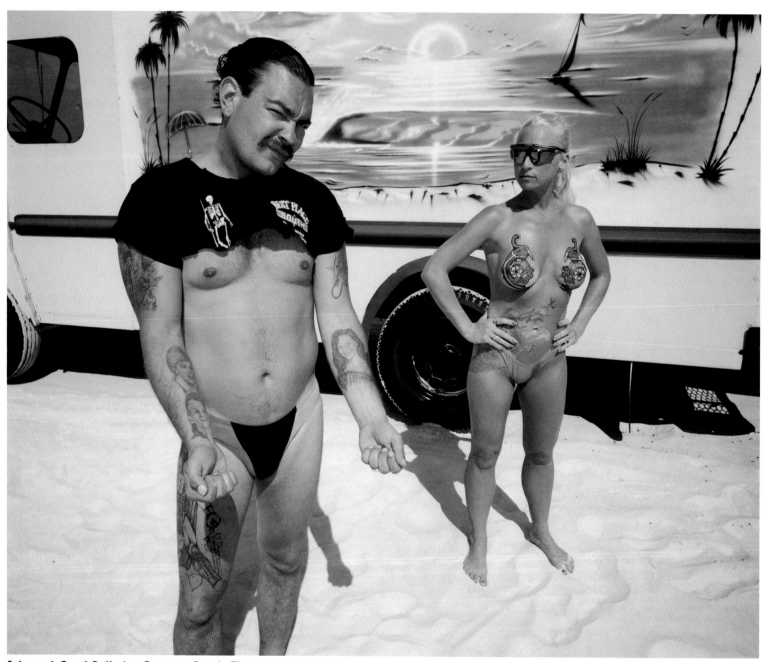

Jake and Carol Ballering, Daytona Beach, FL

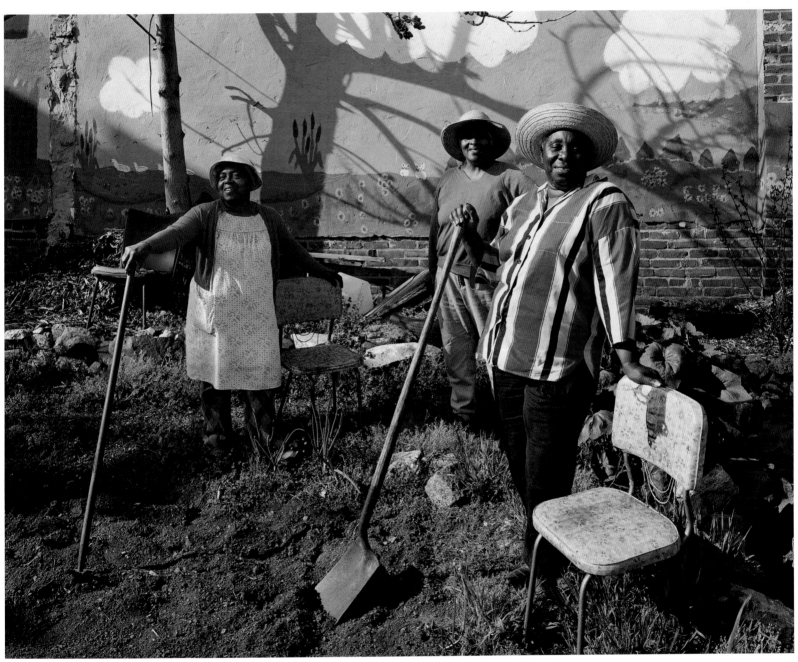

Mrs. Jackson and Friends, Point Breeze, Philadelphia, PA

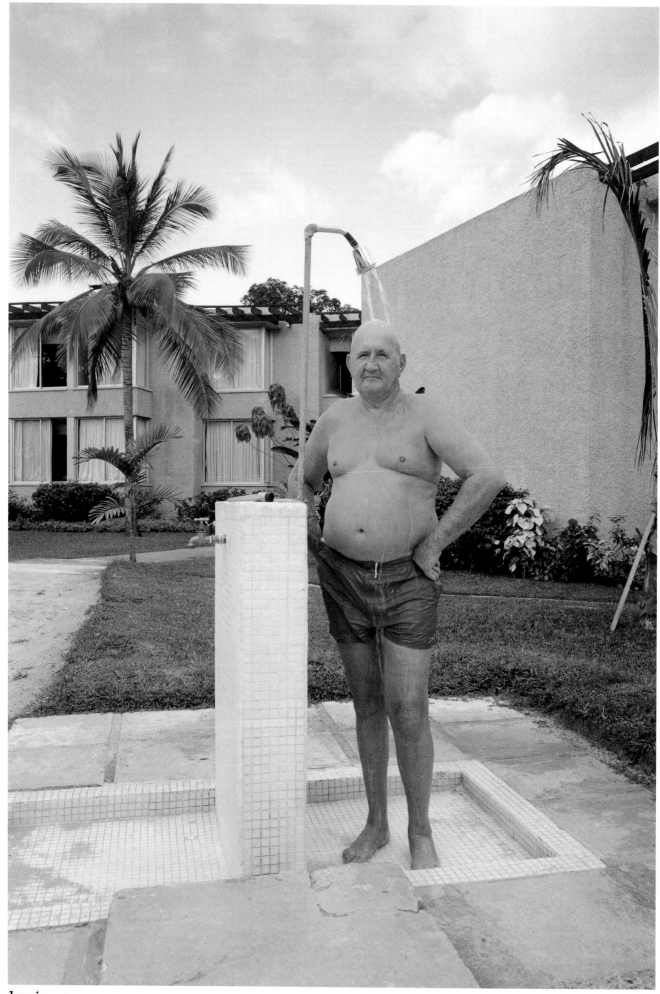

Jamaica

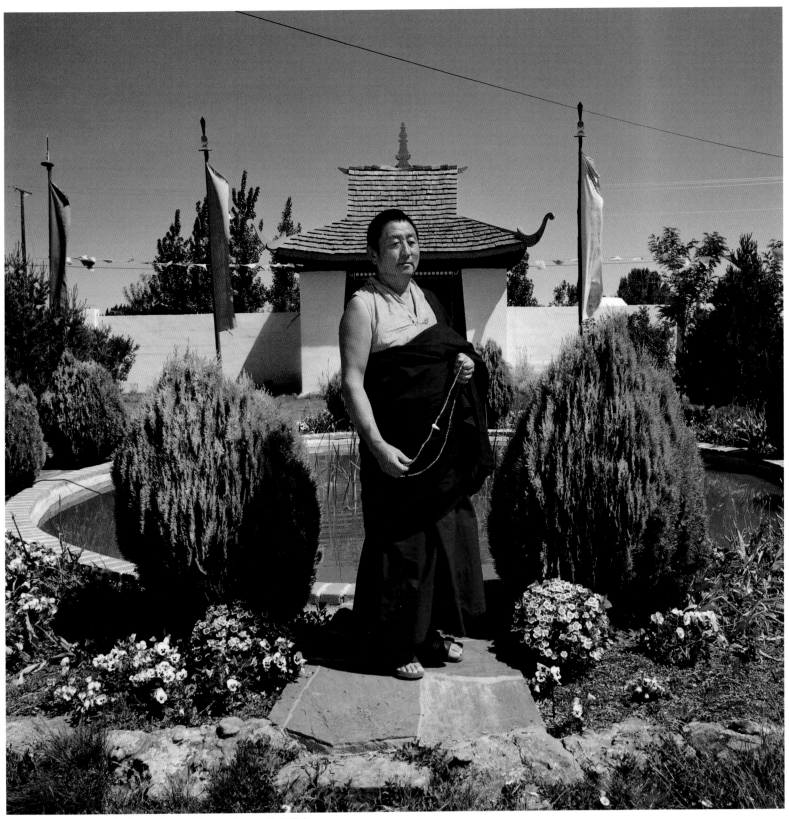

Lama Karma Dorji, before Tibetan Stupa, Santa Fe, NM

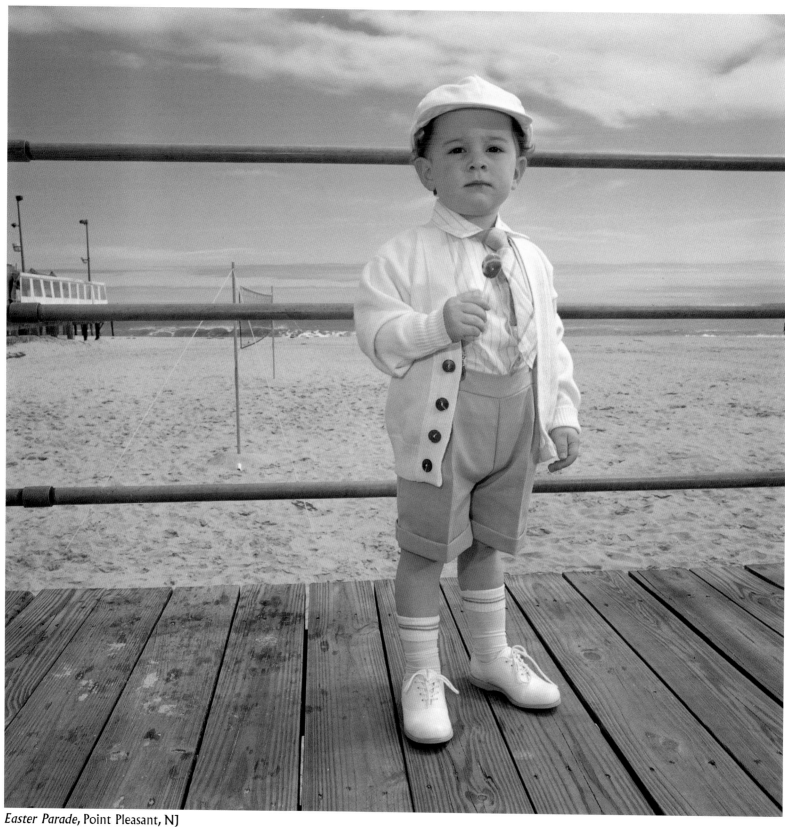

Easter Parade, Point Pleasant, NJ

APERTURE GRATEFULLY ACKNOWLEDGES

GENEROUS SUPPORT FOR THIS PUBLICATION FROM

LYNNE AND HAROLD HONICKMAN

THE PFUNDT FOUNDATION

MARION BOULTON STROUD

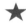

ADDITIONAL SUPPORT WAS GENEROUSLY PROVIDED BY

MARTY MOSS-COANE AND JIM COANE

DANA AND NEIL COHEN

PAULA AND MARK CRAIG

PENNY ETTINGER AND KRIS BAUMAN

SUSAN AND WALT ETTINGER

JIM AND BETSY FROYD

STEPHEN AND JEANNE HAECKEL

CHICK AND CHERYL KOZLOFF

JUDITH AND FRANK NORRIS

DIANE B. VANNAIS AND CHARLES WALDREN

*L*IMITED-EDITION PRINTS FROM *LAND OF THE FREE*

SINGLE PRINT

A limited-edition 20-by-24-inch Chromogenic print of *Mummers Parade*, New Year's Day, Philadelphia, PA (page 56) is available through Aperture. The edition is limited to one hundred prints and ten artist's proofs, printed, signed, and numbered by David Graham.

GRAND DELUXE PORTFOLIO

A Grand Deluxe Portfolio of five 20-by-24-inch Chromogenic prints, printed, signed, and numbered by David Graham, is also available through *Aperture*. The portfolio, limited to an edition of thirty copies and five artist's proofs, includes *Mummers Parade*, New Year's Day, Philadelphia, PA (page 56); Yosemite National Park, CA (page 72); *Orange Dave*, Taos, NM (page 80); *Easter Parade*, Point Pleasant, NJ (page 90); and *Mrs. Jackson and Friends*, Point Breeze, Philadelphia, PA (page 87).

Additional prints from LAND OF THE FREE *are available upon request.*

For further information, contact Aperture's Burden Gallery
20 East 23rd Street, New York, New York 10010
Phone: (212) 505-5555, ext. 325. Fax: (212) 979-7759

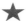

Library of Congress Catalog Card Number: 99-63143

Hardcover ISBN: 0-89381-871-2

Book and jacket design and typesetting by Wendy Setzer

Separations by Bright Arts (H.K.), Ltd., China

Printed and bound by Sing Cheong Printing Co., Ltd., Hong Kong, China

The Staff at Aperture for *Land of the Free* is:
Michael E. Hoffman, Executive Director
Michael L. Sand, Editor
Stevan A. Baron, Production Director
Lesley A. Martin, Managing Editor
Helen Marra, Production Manager
Rebecca A. Kandel, Editorial Assistant
Elaine Schnoor, Production Work-Scholar

APERTURE FOUNDATION BOOKS ARE
DISTRIBUTED INTERNATIONALLY THROUGH:

CANADA: General/Irwin Publishing Co., Ltd., 325 Humber College Blvd., Etobicoke, Ontario, M9W 7C3, Fax: (416) 213-1917.

UNITED KINGDOM, SCANDINAVIA, AND CONTINENTAL EUROPE: Robert Hale, Ltd., Clerkenwell House, 45-47 Clerkenwell Green, London, United Kingdom, EC1R OHT, Fax: (44) 171-490-4958.

NETHERLANDS, BELGIUM, LUXEMBURG: Nilsson & Lamm, BV, Pampuslaan 212-214, P.O. Box 195, 1382 JS Weesp, Fax: (31) 29-441-5054.

AUSTRALIA: Tower Books Pty. Ltd., Unit 9/19 Rodborough Road, Frenchs Forest, Sydney, New South Wales, Australia, Fax: (61) 2-9975-5599.

NEW ZEALAND: Southern Publishers Group, 22 Burleigh Street, Grafton, Auckland, New Zealand, Fax: (64) 9-309-6170.

INDIA: TBI Publishers, 46, Housing Project, South Extension Part-I, New Delhi 110049, India. Fax: (91) 11-461-0576.

Aperture Foundation publishes a periodical, books, and portfolios of fine photography to communicate with serious photographers and creative people everywhere. A complete catalog is available upon request. Address: 20 East 23rd Street, New York, New York 10010. Phone: (518) 789-9003. Fax (518) 789-3394. Toll-free: (800) 929-2323. Visit Aperture's website: http://www.aperture.org

For international magazine subscription orders to the periodical Aperture, contact Aperture International Subscription Service, P.O. Box 14, Harold Hill, Romford, RM3 8EQ, United Kingdom. One year: $50.00. Price subject to change.

To subscribe to the periodical Aperture in the U.S.A. write Aperture, P.O. Box 3000, Denville, New Jersey 07834. Toll-free: (800) 783-4903. One year: $40.00. Two years: $66.00.

First edition
10 9 8 7 6 5 4 3 2 1